W9-CLD-569

FOLK ART MOTIFS

OF

PENNSYLVANIA

Frances Lichten

DOVER PUBLICATIONS, INC.

NEW YORK

Copyright © 1954 by The Estate of Frances Lichten.
All rights reserved under Pan American and International Copyright Conventions.

Published in Canada by General Publishing Company, Ltd., 30 Lesmill Road, Don Mills, Toronto, Ontario.
Published in the United Kingdom by Constable and Company, Ltd., 10 Orange Street, London WC 2.

This Dover edition, first published in 1976, is an unabridged republication of the work originally published by Hastings House, Publishers, New York, in 1954.

DOVER *Pictorial Archive* SERIES

Folk Art Motifs of Pennsylvania belongs to the Dover Pictorial Archive Series. Up to ten illustrations may be reproduced on any one project or in any single publication, free and without special permission. Wherever possible, include a credit line indicating the title of this book, author and publisher. Please address the publisher for permission to make more extensive use of illustrations in this book than that authorized above.
The reproduction of this book in whole is prohibited.

International Standard Book Number: 0-486-23303-0
Library of Congress Catalog Card Number: 75-28849

Manufactured in the United States of America
Dover Publications, Inc.
180 Varick Street
New York, N.Y. 10014

Acknowledgments

My gratitude goes out to Katherine Milhous, Kathleen Sheridan, and Selma Lifschey for their aid in preparing the manuscript and to the collectors, dealers, societies, and museums for use of their material. Above all, I wish to thank Atkinson Dymock, whose knowledge, taste, and whole-hearted interest in his work can always be relied upon to produce a beautiful book.

Motifs to which no locations have been allotted are taken from notebook sketches made here and there over a period of years. As I began this collection of sketches not with a book in mind but from an interest in the subject, I did not note down their source—an oversight for which I offer a blanket apology.

COLOR ILLUS.

NUMBER

1. Schwenkfelder Library, Pennsburg, Pa.
2. The Reading Public Museum and Art Gallery, Reading, Pa.
3. Mr. Paul Auman, Key West, Fla.
8, 9. Schwenkfelder Library, Pennsburg, Pa.
10. Mr. Paul Auman, Key West, Fla.
12. The Bucks County Historical Society, Doylestown, Pa.
14. Schwenkfelder Library, Pennsburg, Pa.
15. The Bucks County Historical Society, Doylestown, Pa.
16. Mrs. J. Stogdell Stokes, Bryn Mawr, Pa.
17. The Reading Public Museum and Art Gallery, Reading, Pa.
18. Mr. Paul Auman, Key West, Fla.
19. Miss Mary Shuler, Napoleon, Ohio.
20. Philadelphia Museum of Art, Philadelphia, Pa.
21. The Bucks County Historical Society, Doylestown, Pa.
22. Mr. Paul Auman, Key West, Fla.
23. Schwenkfelder Library, Pennsburg, Pa.
25. Philadelphia Museum of Art, Philadelphia, Pa.
26. The Reading Public Museum and Art Gallery, Reading, Pa.
27. Schwenkfelder Library, Pennsburg, Pa.
32, 33. The Historical Society of Berks County, Reading, Pa.
34. Schwenkfelder Library, Pennsburg, Pa.
35. Mr. Norman Smith, Lenhartsville, Pa.
36. Schwenkfelder Library, Pennsburg, Pa.
38. Mrs. Maurice Brix, Philadelphia, Pa.
39. Philadelphia Museum of Art, Philadelphia, Pa.

Preface

THIS BOOK is for all those who love the directness and honesty of peasant art, those who are attracted to it by their love of bold color, fine design, and by their feeling for the traditions out of which it evolved.

Above all, it is planned for those who want the pleasure of doing, and having done, want to know what lies behind these peasant motifs, so universal, whose origins go so far back in time. A roster of their very names is indeed an album of time-honored decorative motifs: have we not seen these forms many times before —the tulip, the bird, the heart, the pomegranate, the angel, mermaid, lion, the horseman?

Indeed we have, but they were always in books, books on *European* peasant arts. How then is it possible that they were used in *this* country, in rural regions of Pennsylvania? This book is the result of my search for the answer.

I began to be interested in the whole field of peasant art at a time when there was almost no pictorial material on this subject. Even with eyes alert for any scrap I rarely came across a detail. When I did, I pounced upon it, sketching it or carefully clipping it if that were possible. But with all my eagerness to add to the contents of my folder marked "peasant art," the folder remained a poor thin object. Even a year in Europe did nothing to increase its bulk as I did not travel in any countries where the art of the peasant was an integral part of the national life.

Judge of my excitement, then, to find upon my return that an exhibition of peasant art was being held in my own city, Philadelphia, and, what was more amazing, of an authentic peasant art originating in my own state, Pennsylvania. This exhibition of Pennsylvania German folk art made it plain that a truly Germanic folk culture had existed here together with, but quite independent of, that governed by the dominant English pattern. Moreover, it had expressed itself not only in all the ways of daily life but in crafts and decorations as well. These chests and pottery, textiles and metal work —some dating back to the time we were still an English colony—were all stamped with the unmistakable folk touch. They were the work of the craftsmen who were a necessary component of that large group of the state's early settlers, the Pennsylvania Germans. The articles they made brought beauty to the simple folk who carried these motifs in their hearts and memories across the Atlantic Ocean into what are now the lovely farm sections of Pennsylvania. Here, in an area which is in truth the work of their own toil, the Pennsylvania Germans guarded their artistic heritage and held the fort up until the time it was conquered by the power of the Industrial Age.

Ever since this first introduction to the folk art of my own state I have been intent on enlarging my collection of Pennsylvania German motifs. I have literally got down to earth—to the level of tiny worn tombstones almost hidden by grass—in order to sketch the interesting designs cut in their weathered surfaces. I have peered earnestly at dower chests whose painted patterns were nearly obliterated so that I might save a motif which might otherwise have gone unrecorded. This study enabled me later to give definition to lines and forms which to some might appear to be but vague smudges. Why did I do this? Because as artist and designer I realized the importance of an untouched field of inspiration to those interested in the decorative arts.

In 1946 my book, *Folk Art of Rural Pennsylvania,* made much of this material available to those not fortunate enough to see the original examples. It furnished designers, artists, and teachers in particular with new artistic ideas which they have since adapted to many purposes. Indeed much of the material was used with such enthusiasm that it has become very familiar. It seems to me, therefore, that it is now time for a new book of motifs to be offered; motifs far less well-known but quite as authentic and useful as artistic inspiration in teaching the elements of design to others or simply for one's own pleasure.

Here is that fresh collection from my sketch books in all its gaiety and gusto. The craftsmen who long ago employed the attractive motifs shown here may not have drawn or painted with professional skill—as we

understand the term—but they used the forms with such directness that we can do little to improve them. We can, however, learn much from them and in adapting them to our own uses, add new charm to possessions and beautify our surroundings.

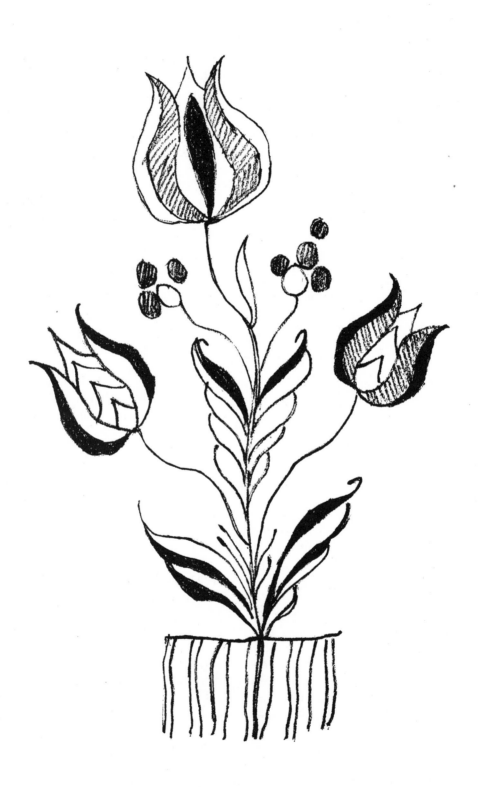

Contents

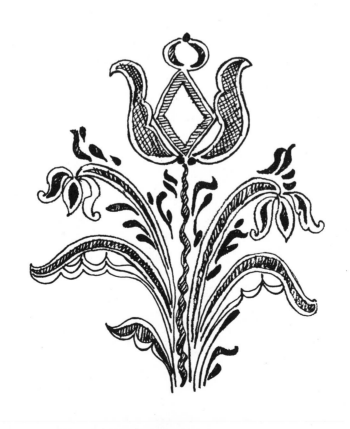

Introduction

THE FOLK ARTS of the Pennsylvania Germans have been the subject of much interest during the last two decades. In rural areas of Pennsylvania where these European immigrants settled in early Colonial days, there has been lively search for examples of their arts. Now brought to light, these expressions of an indigenous folk art have attracted the attention of designers and decorators, art educators, and homemakers as well.

Until quite recently there had been practically no interest evinced anywhere in the arts of the people. Except by a few quiet collectors folk art had been ignored. There were no collections of this material in museums, either in Europe or here; the art productions of the folk were not subjects with which most cultivated persons were in sympathy. But around 1925, both here and abroad, interest in the folk artist and his work suddenly sprang up. The work of the old-time Pennsylvania German craftsmen was ferreted out of quiet corners where it had lain hidden for a century or so, the sharp light of publicity focused upon it and at once it attracted attention.

Here was something new for antique dealers, a field hitherto untouched! Here, too, was something different for the American press. Newspapers and magazines began to picture various phases of Pennsylvania German culture —the culture which this folk had peacefully sustained ever since its forebears settled in the state over two hundred and fifty years ago.

As a result of all this publicity *Pennsylvania German* (or Pennsylvania *Dutch* as it is colloquially known) has become a household word. It is a term which has also acquired a decidedly commercial value. For this additional popularization we can thank American business enterprise. In the enthusiastic discovery of something novel, certain commercial circles applied the term "Pennsylvania Dutch" to productions decorated with patterns that have only the most tenuous relation to the original motifs. By prettying them up their naïveté of line and color has been destroyed—and it is on naïveté that much of the charm of Pennsylvania folk art is based. As a student of these designs I find such enrichments and distortions regrettable. The source material itself has a simplicity that cannot be altered—at least noticeably—without losing its intrinsic character.

So far I have been discussing applied design only, but now I want to talk briefly of the objects to which the designs were applied—chests, pottery, rugs, etc. All of these articles have been pushed to the fore by the above-mentioned publicity. Even though helped by such popularization, the interest in Pennsylvania German furnishings and folk motifs would never have become so widespread had it not been for recent great changes in the American manner of living—changes which came about through the trend toward country life, made possible by the automobile. With a car, rural life, hitherto very difficult of attainment for city dwellers, suddenly became a feasible thing. People began to search avidly for old houses. When found, they earnestly went about remodelling them. If they could not find an old house, they built a new one along old lines. This return to a Colonial setting was accompanied by a desire for simplicity and ease of maintenance. Women busy with outside interests were neither willing nor able to spend as much time taking care of elaborate and easily damaged possessions as were their Victorian ancestors. Such homemakers, looking about for things easier to care for, yet in harmony with their "early American" houses, turned to the sturdy handmade objects once characteristic of rural life. Thus the Pennsylvania German piece came into its own.

Pennsylvania German antiques make themselves at home at once in contemporary surroundings. In their attractive simplicity they are as much in harmony with the "pioneer manner" of what has now become fashionable living—the knotty pine, hooked rug, earthenware table service scheme—as were the Turkey carpet and Lowestoft china with the elegant furniture of Messrs. Chippendale and Sheraton. We of today, perhaps unconsciously sated with the machine-made, take a nostalgic delight in these early household furnishings. We appreciate the honest workmanship and the suitability to purpose—qualities fundamental to an era when the hand and eye of the craftsman prevailed. With all the machine's endless capabilities directed by the taste of fine designers at our

command, nevertheless we willingly pay high prices for these simple belongings of the early Pennsylvania settler. Futhermore, we even copy these pieces if we can't afford the old ones. And we search out the motifs of the Pennsylvania German artist and then find new ways to use them on articles we surround ourselves with. Whether we are aware of it or not, our affection for these rude pieces is assuredly based on a longing for the past they evoke—for that time when life was founded on essentials, and nature, not the atom bomb, was all that was to be feared.

Such humble antiques were made by the artisans who were an integral part of all early communities. Because of conditions prevailing at the time, the rural craftsman was isolated from changes brought about by fashion; consequently his work was rarely affected by what was modish. He carried on his trade as he had been taught it, letting himself be guided by tradition and the needs of his customers. The latter, simple folk and equally untouched by fashion's whims, were content to have the artisans duplicate the household gear they were accustomed to see about them.

In all probability this was the way of the rural artisan everywhere, but nowhere in pioneer America was this more true than in the southeastern area of Pennsylvania, a section settled in the late 17th and 18th centuries by immigrants from the Rhenish Palatinate and Switzerland. These folk as well as their descendants are known today as the *Pennsylvania Germans* or *Pennsylvania Dutch*. The variation in terms is indicative only of a cleavage between the scholar and the folk. It has nothing to do with a difference in national origin. Persons native to this section always refer to themselves as "Pennsylvania Dutch." (Dutch was the historic label used for centuries by the English when alluding to the inhabitants of Germany. It is a corruption of *Deutsch*.) Because I grew up in this part of Pennsylvania, I, too, use the everyday term when speaking about them. On the other hand, when writing, I join those who consider that the term "Pennsylvania German" is more accurate for descriptive purposes, since it evokes a truer picture of the historic background.

Except as circumstances compel them to, people do not alter their way of life when they emigrate, and certainly no more than they have to. Of habit they conduct their lives in much the same manner as they did in the old world. The early settlers of Germanic stock in Pennsylvania followed this familiar pattern.

Since they spoke no English, for mutual convenience they lived in communities. These settlements were surrounded by the dominant population of the state, which was English. Snug behind this language barrier, they remained untouched by outside influences, maintaining their own culture in all its phases.

Their arts are but one expression of this Germanic culture. That is why the ornamented articles produced by their craftsmen, whether of painted wood or punched tinwork, of ceramics or of iron, strike an odd note in collections of Americana. At sight, any such piece at once summons up a picture of something distinctively European. In consequence one wonders, unless acquainted with its history, how an object that appears to be so foreign happened to be made here. The reason for its old-world quality must be told.

In the 17th century certain areas along the Rhine and in the region known as the Palatinate were being fought over in one of the endless wars that European states and their rulers engaged in in their perennial struggle for power, both political and religious. So devasted finally was the region that the population—at least the Protestant portion of it— could hardly maintain life. Everything they owned, lived for, struggled for had been taken from them. Whole families were wiped out and those who were left to face life could not see one ray of hope for any betterment of their dismal condition. (In those days one could not look forward to relief from overseas, as America itself was only an infant.) But when word of America was carried to the war-ravaged, the new country became, then as now, a fertile seed-bed for the hopes of the displaced and destitute. Finally Hope appeared in the person of William Penn. This inspired man and his agents journeyed through the stricken countryside searching for persons willing to settle the great grant of land given to Penn in far-distant America. Those who listened to this good man heard him offer them land, land to till for themselves, freedom to practice their own religious beliefs and the opportunity to build a new life with their own hands.

With such inducements it was not necessary to urge people to settle in Pennsylvania. After 1683 and for decades thereafter, many thousands attempted the dangerous journey. The voyage, especially in the earlier days, was a dreadful one, and many colonists died en route. By the time the survivors arrived in the promised land they were already inured to practically any hardships pioneer life might present. And, as a matter of fact, very few of them grumbled or complained. Instead, they were filled with an overwhelming sense of relief at their escape from woeful Europe. Before they came they knew very well that life here would be hard and work unending. And their submission to this bitter knowledge was to bear rich fruit.

It probably took the colonists all of several generations to root themselves solidly in Pennsylvania's rich soil, and not until they considered themselves well established did the German settlers in Pennsylvania give way to their long-repressed love of color and decoration. A rough guess, judging by the objects which bear dates, would place this revival of the more decorative aspects of folk life somewhere around 1765. The memory of the things their handicrafts had produced in the old country was doubtless kept alive and constantly refreshed by the new arrivals coming in in a fairly steady stream, year after year.

Now, with a little free time on his hands, the elderly carpenter could hark back to the furniture which had been the dowry right of the maiden in the old country —the brightly decorated chest, the cupboard and ward-

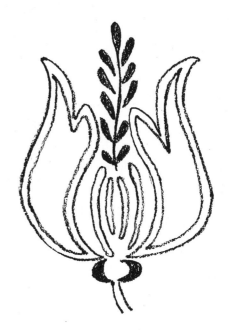

robe which were her parents' gifts to her when she set up her own establishment. Inspired by this image, he tried to make finer pieces than he could manage in the ordinary run of his orders.

Now, spinning before the fireplace, a woman could pause in her endless drudgery to dream of the embroidered linens, the colorful bedding that the European housewife prized so highly. With this picture before her, she decided that, whenever she had a few free moments, she would teach her daughters how to make such textiles for their dowry linens. Girls spent their free time in accumulating their stock.

Now, the old blacksmith, thinking back to his apprentice days in the homeland, would hammer out of the red-hot iron a gracefully scrolled hinge. This was a more intricate one than he usually made, for he ordinarily had little time for flourishes in his work. At the moment, however, no one was clamoring for the vital necessities of life—a crane for a fireplace, a fork for the cook-pot, a latch for the door. As sparks flew steadily from under his hammer, he found enjoyment in the fact that he had not forgotten the finer aspects of his ancient craft.

It was in some such manner that the folk arts of the Pennsylvania "Dutch" came to life. True, they varied in small ways from the European patterns, for the craftsmen had only their memories as guides. They had brought

with them no actual models. In the days of those tiny and crowded vessels, no one could possibly bring much more than a few pieces of clothing with them, plus the vital tools with which to start a new life, and, of course, a Bible.

Because of this lack of prototypes and of special equipment, everything the Pennsylvania craftsman turned out from memory was likely to be simpler than its European original. Furthermore, details which in Europe would have been executed in carving or in turnings were here simulated—and with the most engaging naïveté—in paint. In achieving a decorative effect, painting was speedier than carving, and time was not to be wasted on needless work in this new country, no matter how skilled one was or how deep-rooted the love of ornament might be.

The folk decorator rarely functioned as creative artist; his clients, pleased to obtain any new object, did not expect originality in his production. Instead, he worked with traditional forms which had been refined through centuries of use, and were well-rooted in the folk memory. The time-honored motifs fall into a few groups. Found on the early pieces are the tulip or lily, the heart, a variety of bird forms, star and geometrical shapes, the stag and the unicorn, the urn, strange mermaids and odd cherubs and angels. Later on, as ideas of decoration from other cultures infiltrated these communit-

3

ies, the craftsmen united these alien ideas with their traditional motifs, an innovation which often created some startling effects. But as long as the folk artist held to his traditional patterns, the work of his hands, though often untutored in quality, was unquestionably sound in design. He had a fine feeling for space arrangement, frequently coupled with but slight concern for technical proficiency. This indifference to technical skill is particularly noticeable in certain of the Pennsylvania German's illuminated "birth-and-baptismal certificates," or *fractur* drawings as they are called. Though crudely executed, these records of vital statistics are, nevertheless, the last flare-up of an ancient craft—the medieval art of manuscript writing. On these *fractur* drawings we can find a variety of delightful motifs, done in manners which range from the childish to the highest standard one can expect of the folk artist.

But let us not conclude that everything the Pennsylvania Germans used in their households was elaborately decorated. Certain objects have come down to us, it is true, which are highly ornamented, such as ceramic pieces, dower chests, cupboards and wardrobes. But these were pieces kept for "best," for the very fact that an object was decorated marked it at once as something special. For everyday use, nothing was ever ornamented unless the decoration—such as a tulip ending to a fork, the pattern on a buttermold, the pierced openings on a tin "food safe," or the gay figurations on a coverlet—was an integer of its construction. From this statement we must, in all honesty, exclude the humble brown earthenware pie plates. Although these were the most ordinary of articles, they usually bore a few yellow swirls of decoration. These flourishes took but a few seconds to apply and so the potter usually found time to add what was frankly a purely ornamental touch. This was not only pleasing to the eye but added a few frills to sober surroundings at a time when all life was workaday and every glimpse of beauty, even a squiggle on a pie plate, a rarity to be cherished.

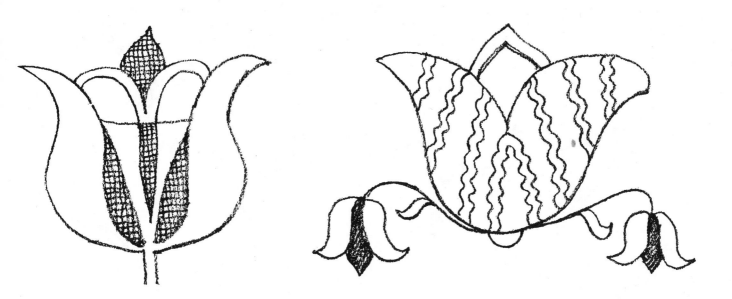

THE TULIP

A tulip-like flower form is the outstanding feature of Pennsylvania German folk art. The term "tulip-like" is used advisedly, as this formalized tulip is obviously not inspired by the variety grown in gardens; rarely do the large basal leaves of the real flower accompany the tulip motif. For them foliage of a decorative character is substituted. This simple form, paralleling that of a tulip seen in profile, can be found in the ornament of European cultures but, except in Hungary, it was never featured so prominently. One may contend that the tulip

was popular with the folk because it was easy to draw. But its constant use by Pennsylvania German artistans—almost to the exclusion of all other floral forms—suggests that there may have been a deeper reason for the dominant position they gave it. Many of these German colonists were guided by mystical forms of religious belief, and in the mystical approach to religion the tulip stands for the lily: a symbol of man's search for God, and a promise of bliss in Paradise. *(See also Color Illus. 1–3)*

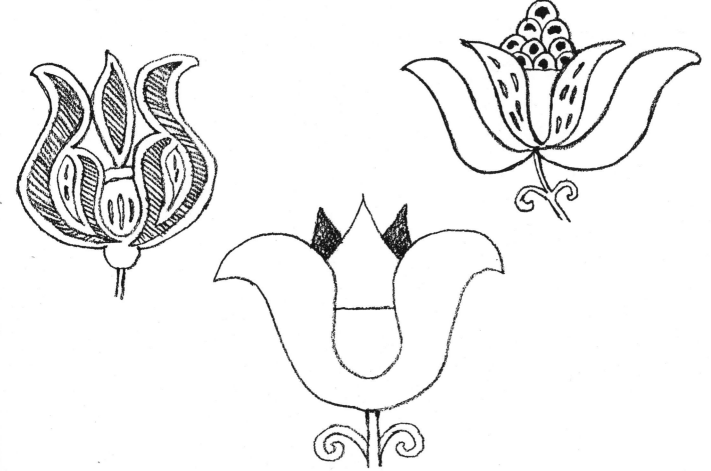

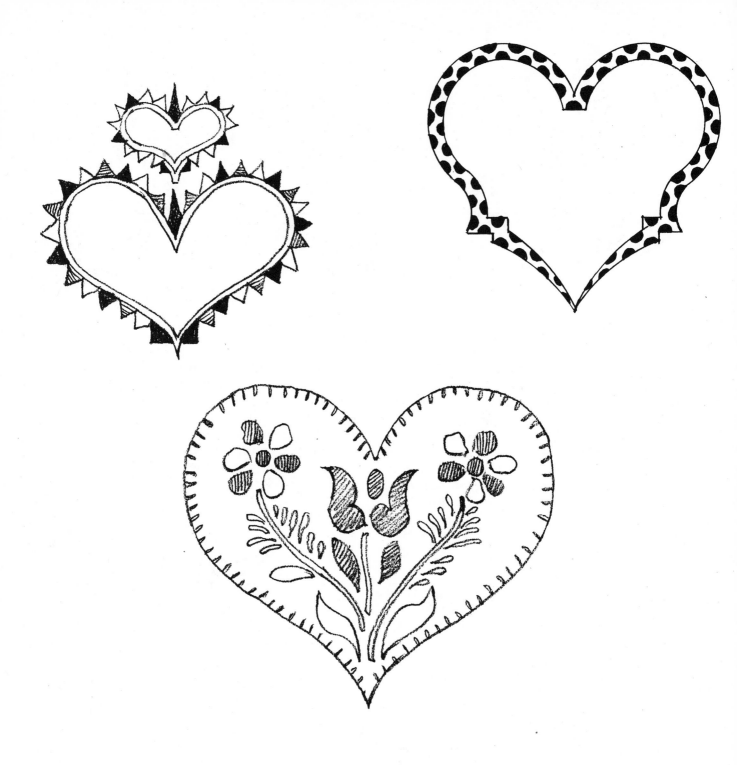

THE HEART

Though the heart is not used quite as frequently as the tulip in Pennsylvania German decoration, it is encountered often enough so that one does not err in linking it with the tulip as a favorite motif. The heart is shown most often with other ornamental forms. It is a dominant note on many birth-and-baptismal certificates, where it serves to enclose religious texts and vital statistics. Many times it was carved on buttermolds and on gravestones, and painted or inlaid on dower chests. One should not assume, however, that this heart is the sentimental heart of the valentines. Rather it is religious in significance, and in symbolic interpretations of folk art it represents the heart of God, the source of all love and hope of a future life. Only after the Victorian romantic period arrived did the Pennsylvania Germans adopt the heart as a sentimental symbol. Then maidens worked it in appliqué on their "bride's quilts" or embroidered it with their own and their fiancé's initials on "show towels." The latter were traditional pieces of decorative needlework which constituted part of a trousseau. For special occasions they were hung on the doors to display their maker's proficiency in needlework.

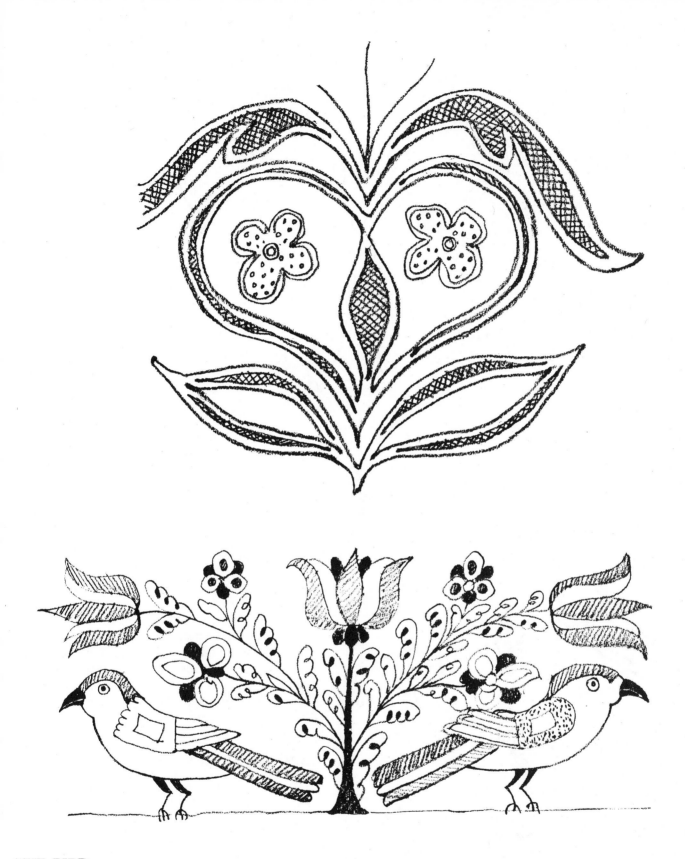

THE BIRD

One would find it difficult to identify the species of most of the birds which add a touch of life to the stylized tulips and other forms in Pennsylvania German decoration, but they are always recognizable as birds, no matter how crudely they are depicted. Birds seem to be a form which all peasant artists loved to draw, perhaps because of their simple contours or because they are so much a part of the everyday world. Within the boundaries set by the uncomplicated outlines of the bird, the untutored craftsmen evolved original, sometimes fantastic conceptions, and with simple patterns used for feathers and rhythmic lines for tail they devised many pleasing decorative effects. *(See also Color Illus. 4–9)*

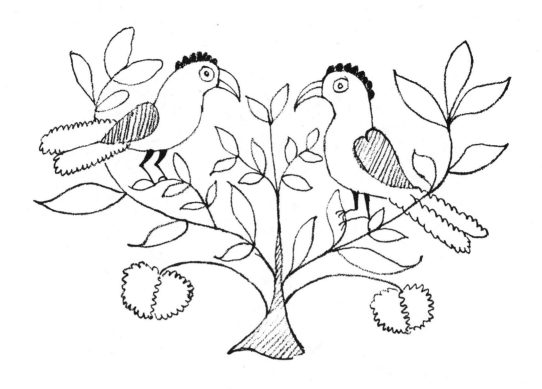

THE BIRD

Birds in pairs supplied an interesting focal point in decoration, whether set beak to beak, tail to tail, or poised in alternating positions on slender branches. Some craftsmen, seeking inspiration, from time to time found it in the pair to the left. This was a motif easily come by, as it was an integral part of most 19th-century birth certificates printed from woodblocks, and many families possessed these printed baptismal records.

BIRD DRAWINGS

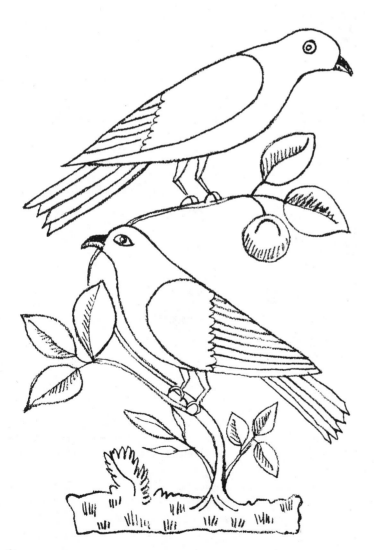

In Pennsylvania German schools in early days drawings of birds were prizes for good conduct. The schoolmaster would paint birds or decorative designs on small squares of paper. These colored pen drawings were called "Rewards of Merit." Because any bit of freehand art was then a rarity, these little drawings were highly valued by their owners as examples of painting. To preserve them they were slipped between the pages of a book, usually the Bible, often the only book which a family possessed. Thanks to the reverent care given the Bible through the years, today we can enjoy these quaint samples of the teachers' skill and kindheartedness.

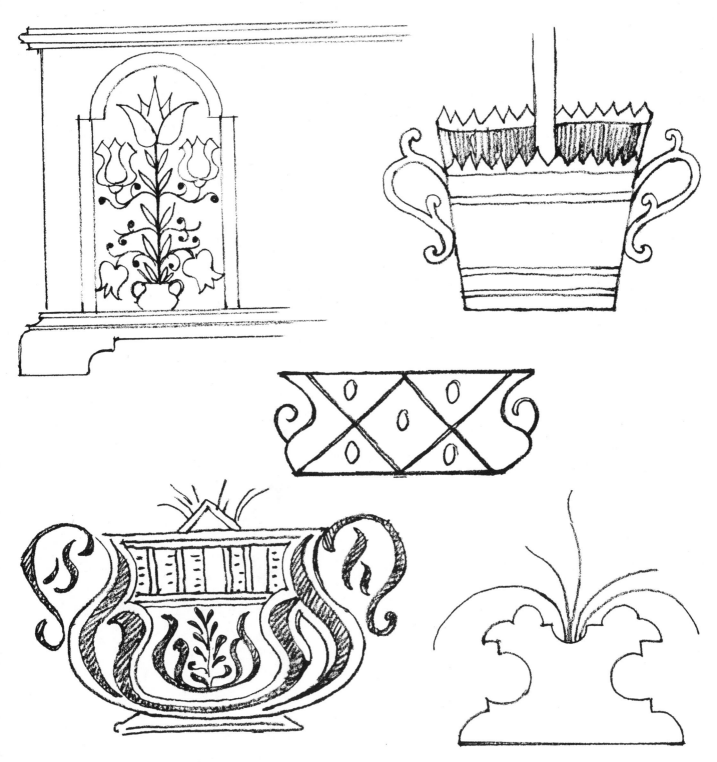

THE URN

As an ornamental motif, the urn made its appearance in the early 16th century and has been closely linked from that time on with Renaissance design. During the Renaissance the urn motif was used in a wide range of decorative arts, from textile to bas-reliefs. In the rugged civilization which was developing here, life was completely divorced from the elegance and opulence of Europe. Therefore one would not expect to find any phase of Renaissance decoration in our primitive rural life. Yet even here the folk artist, working only from memory, used the urn in decoration exactly as did the more sophisticated

artisans of his homeland. Their favorite choice for ornamenting dower chests were urns holding sprays of flowers. As the local decorator lacked models, the urns he painted have but little of classic grace. Furthermore, rarely did the urns appear adequate to support the floral sprays; the latter always seem quaintly top-heavy for the tiny holders. The folk artist's urn had two handles and often resembled an 18th-century pewter mug. There are some shaped like baskets, others suggest a cross-section of architectural molding. In symbolic language, the urn signifies the Holy Grail.

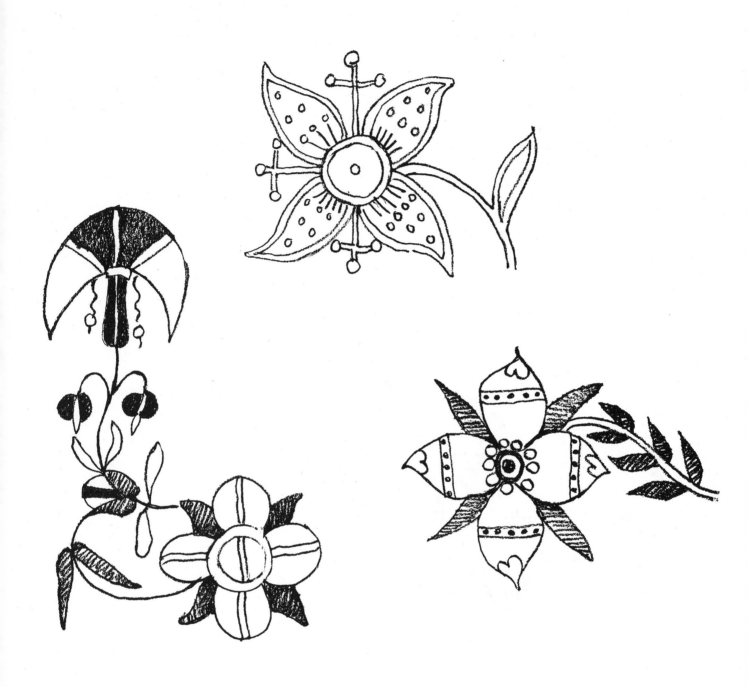

CONVENTIONALIZED FLOWER FORMS

Since the tulip can be found on most examples of decoration of Pennsylvania German origin, it has become almost its trademark. Nevertheless, there are many other stylized forms besides the tulip—ornamental devices which will surprise us by their variety if one searches for them. We find that many of these motifs have a geometrical foundation and as Nature constructs most flowers on an orderly plan it is possible to trace a pictorial relation be-

tween the folk artist's rhythmically constructed floral inventions and those of Nature. This connection, however, seems to be founded more on fancy than fact, as the art of the peasant in its pure form was never based on an accurate representation of Nature. Folk art may have originally been inspired by Nature, but many generations of human artistic expression transformed it into impersonal decorative design. *(See also Color Illus. 10–13)*

CONVENTIONALIZED FLOWER FORMS

The motif above as well as the one on the opposite page bear witness to the love of decoration which filled the hearts of the folk. Both were found on old tombstones. Although the harmonious arrangement of tulips on the opposite page was worked in relief—the stone cutter's usual technique—the one above was incised in line. The treatment of all of its details indicates that it was probably the work of a potter. It must have been troublesome to execute for a potter used to scratching lines in the unresisting surface of clay, rather than in stone. But in the days when few could draw at all, there must have arisen many occasions when an artisan skilled in one field was called upon to work in less familiar media.

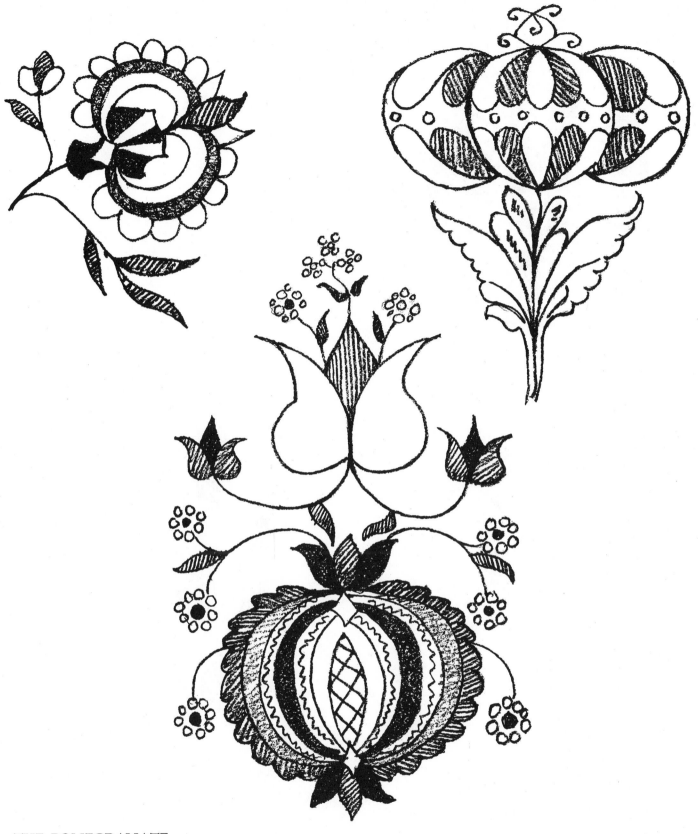

THE POMEGRANATE

Symbol of both fecundity and immortality, the pomegranate is a design form of ancient lineage. It was represented in Assyrian and Egyptian sculpture as well as in that of the Greeks and Romans. In the Dark Ages it seems not to have figured in decoration, but by the early 15th century it again took on importance. Indeed, it would be difficult to find a textile design produced in Europe at any time during the Renaissance period in which the pomegranate was not featured, or at least incorporated in minor details. One need not be surprised, therefore, to find that this fruit (though an exotic in America) was used occasionally in Pennsylvania German design. The local craftsman could hardly have overlooked it, since the pomegranate was an everyday motif in his homeland.

15

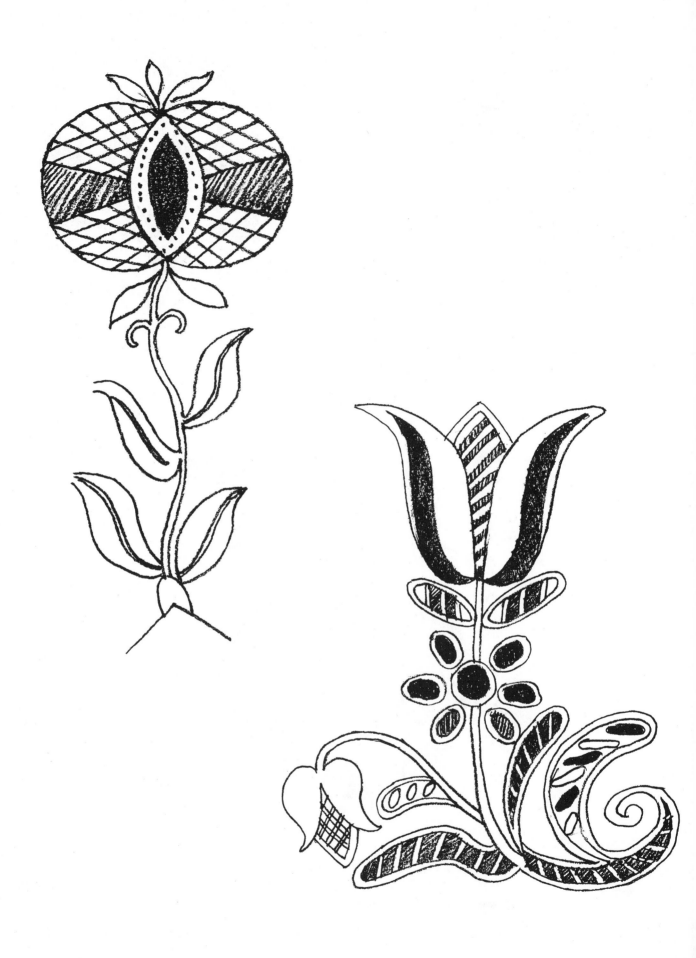

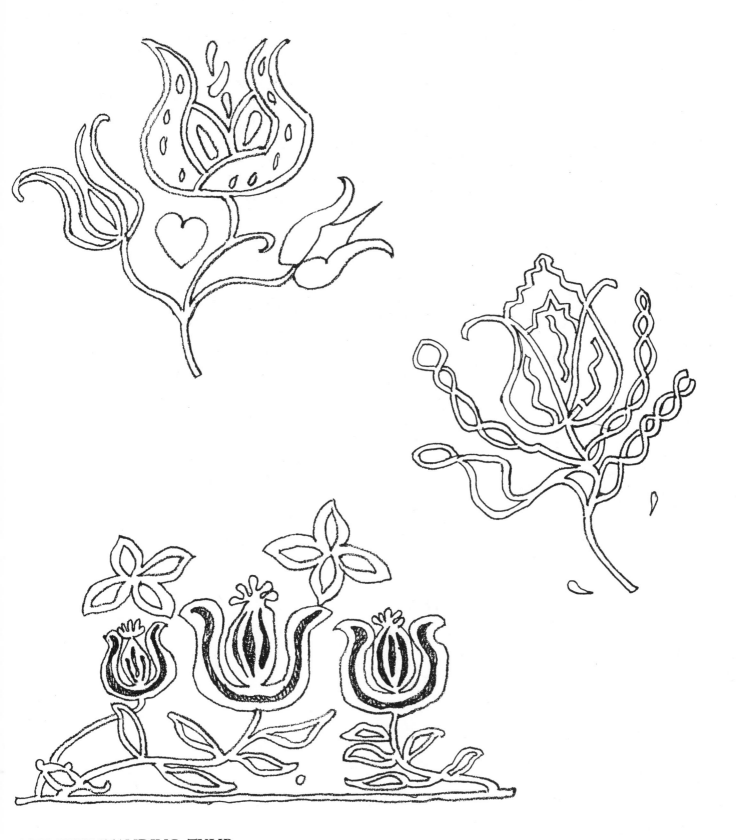

THE FREE-STANDING TULIP

In creating a design, an adherence to bilateral symmetry offers the least problem to the untrained; accordingly, the folk artist's patterns were frequently based on this plan. But once in a while he cast aside this facile solution to design problems and attempted an asymmetrical arrangement, as is shown in the selection of motifs here pictured. Whether used on an early decorated chest of 1768, as was the one on the facing page, or incised on ceramics (upper left and right) or even cut on a modest tombstone, as is the one in the lower left, these motifs have an appealing freshness because of their vivacity of line and the contrast they offer to the formal balance of the majority of Pennsylvania German designs.

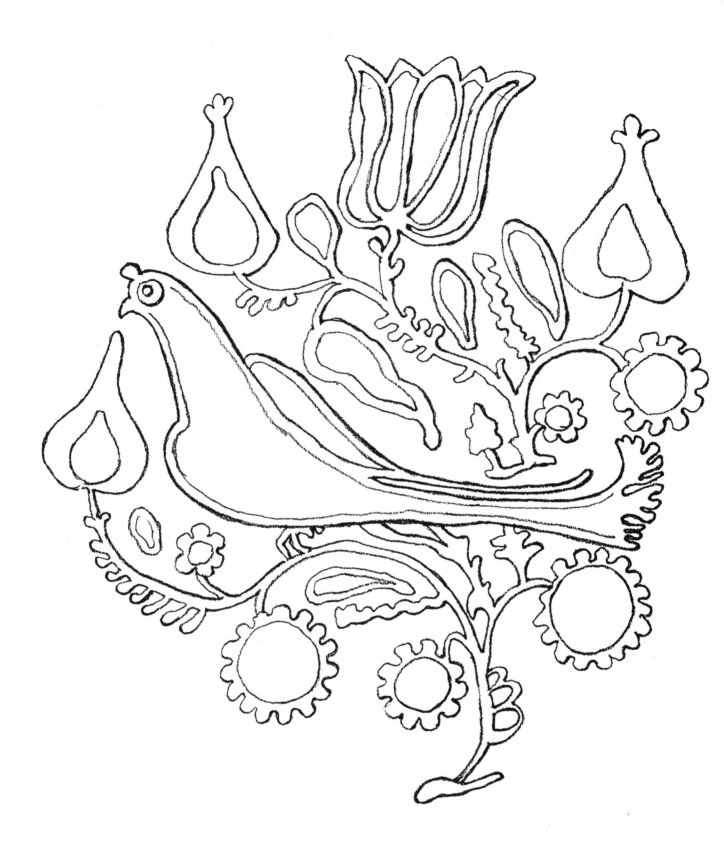

THE FREE-STANDING TULIP

The blunted forms and extreme fluency of this asymmetric composition result from the medium in which the motif was originally developed. Taken from a type of ceramic known as slip-decorated, the design was executed with a clay of the consistency of cream (called "slip").

This thin clay was poured out through a quill attached to a cup onto a ceramic plate of redware. To achieve such distinction in design with this difficult technique demanded great skill.

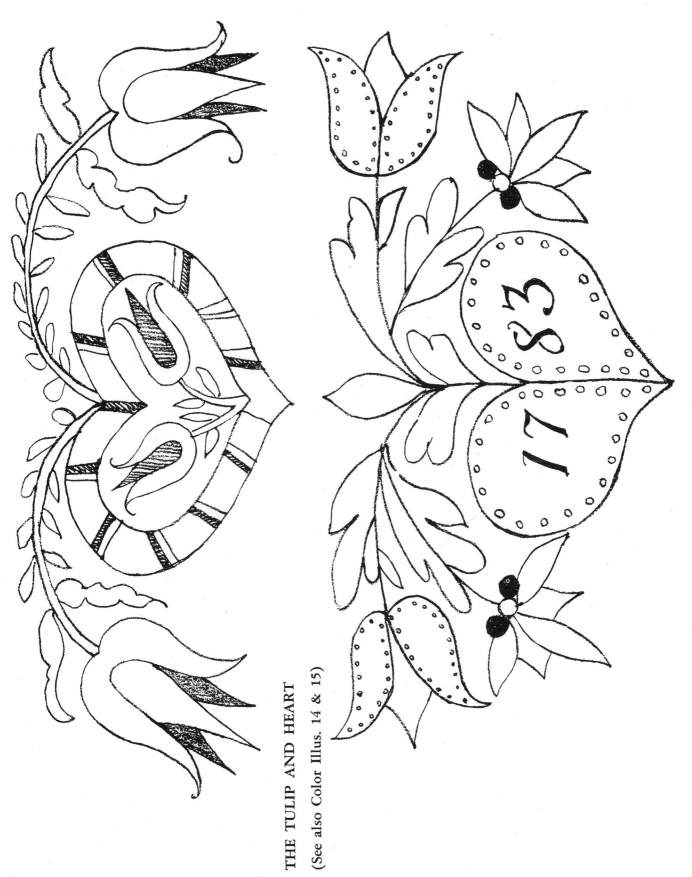

THE TULIP AND HEART
(See also Color Illus. 14 & 15)

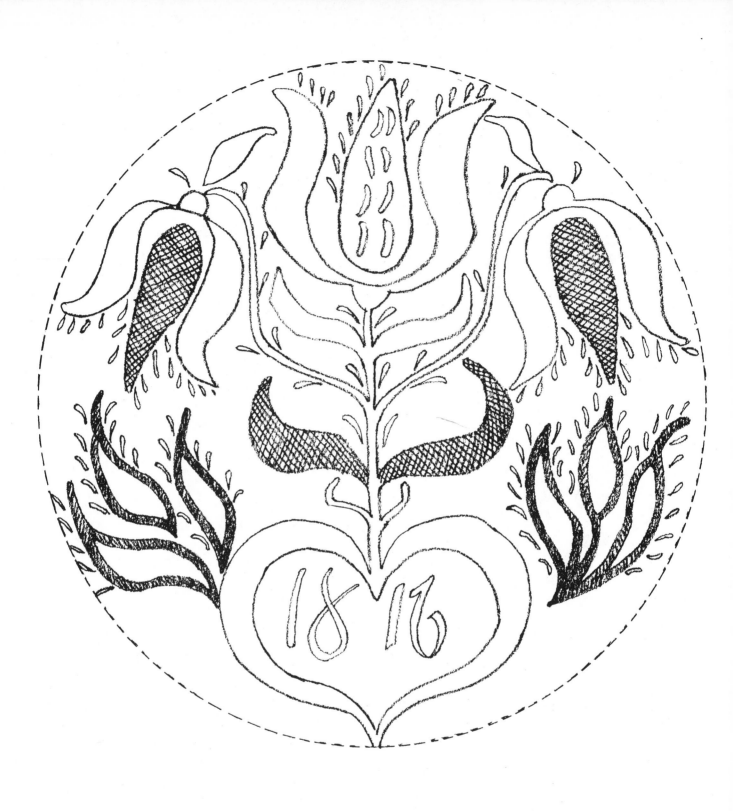

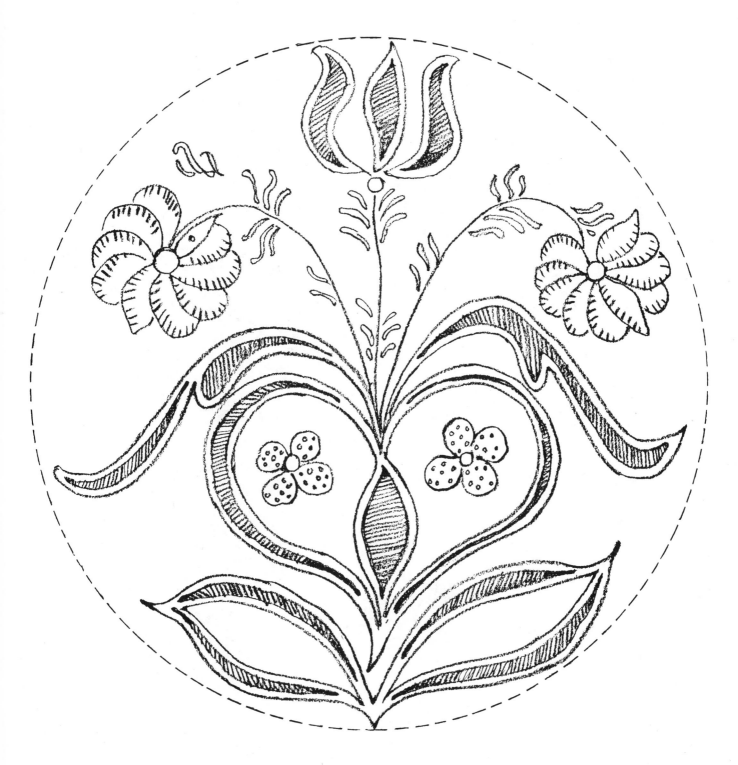

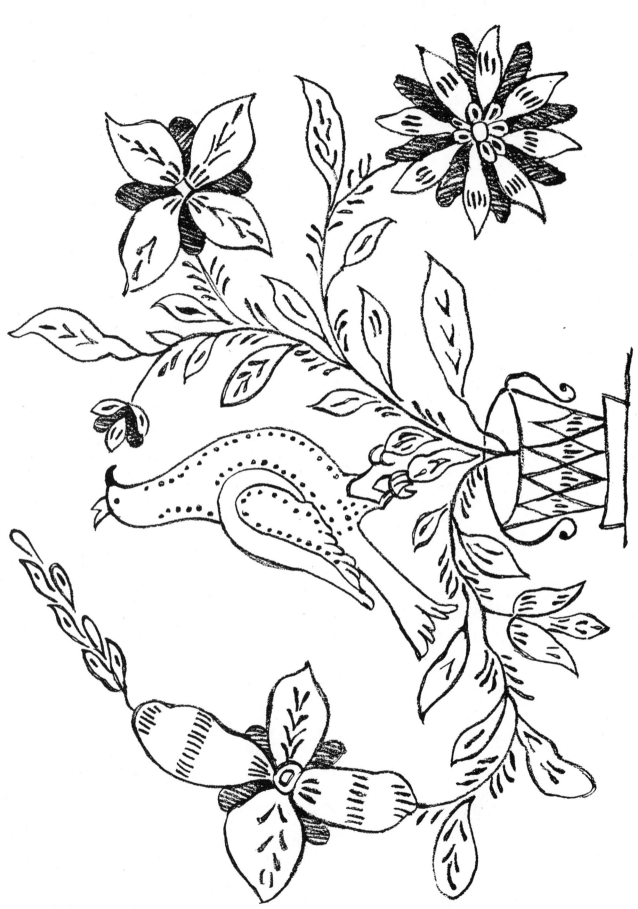

THE TULIP AND URN

Color Illus. 16: The Pennsylvania German decorator juggled and combined his basic motifs in various fashions, as is shown on the preceding pages. Taken from a girl's dower chest is this simple yet charming combination of the tulip and urn. The chest bears the date together with the name of its owner. Such proofs of ownership are more often found on dower chests than on other pieces of household equipment, and point to the high value placed on personal possessions at a time when such things were none too plentiful.

Color Illus. 17: From the panel on a miniature chest, executed with much authority and with a more fluent line than is usual. This motif is by an unknown decorator whose work, in general, maintained a high artistic standard. On certain of the coveted "unicorn chests"—which appear to be by his hand —he has employed the same motifs, but used them in different combinations.

TULIP, BIRD, URN

The position of the bird plucking at its breast indicates that it is meant for the pelican, an ancient symbol. Well known in church heraldry, the pelican is there depicted as feeding the young with blood from its breast. As symbol the bird signified piety or the Atonement. As a decorative motif, the bird with its deeply curved neck survived in local folk art long after the nest of infant pelicans—an integral part of the symbol—disappeared. They were replaced, as time pased, by a tulip or spray of floral devices. In this example of rather late work the urn takes on a heart shape to which inadequate feet are added for support. *(See also Color Illus. 18 & 19)*

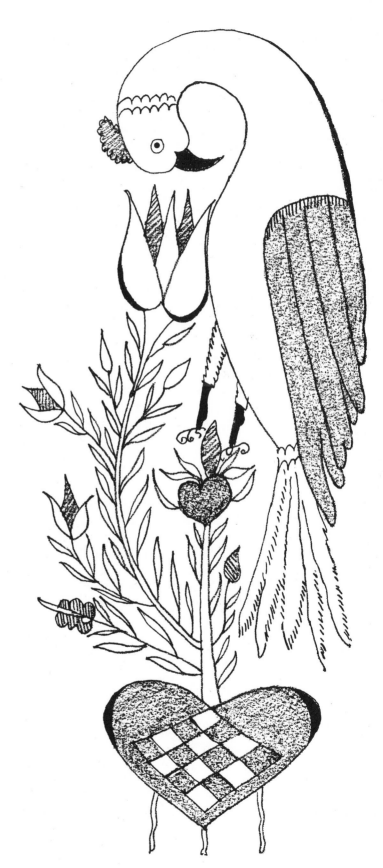

COLOR

There is much discussion as to what constitutes *true* Pennsylvania German color. Most of this discussion is futile. If one examines a variety of decorated Pennsylvania German articles, one finds a variety of hues; there will probably be several reds, and an equal number of yellows, greens, and blues. On certain pieces produced toward the end of the handcraft era, there are oranges, purples, and pinks. With such a range, it is unwise to point to one particular shade and declare, "That is the *true* red. This is the *right* blue."

The reasons for the many variations of color should be obvious. The coloring on any antique object is almost assuredly smudged by the passage of the years; moreover, chemical alterations have undoubtedly taken place. Some 18th-century fractur paintings, if they have been well cared for, preserve much of the identity of the original pigments; the vermilion, gamboge and prussian blue of commerce can be pointed out with certainty. On the other hand, the hues on other pieces of fractur, even though executed about the same time as those just mentioned, will have so altered that one would hesitate to classify them under any accepted color nomenclature.

Craftsmen used but few colors when painting with oil paints. Watercolors embraced a wider range, which was added to as the industrial age expanded. In the early days, pigments of necessity were imported from Europe. By 1824, however, a Philadelphian was already manufacturing watercolor in neat cakes. These were pigments of fine quality which the local fractur painters could certainly have obtained from country merchants or the welcomed peddlers who tramped the roads with articles brought from the city. Consequently there seems little justification for the statement that the artist produced his own pigments. In work appearing during early Victorian days, this broadening of the color range is quite evident. Around the 1840's we find new and striking colors being used: chrome oranges, violets, reds on the purplish-crimson side, and opaque yellow greens. As these strong colors were a stimulating addition to the familiar range of pigments, the later fractur artists made lavish use of them. See Color Illus. 18, in which the artist resorted to these gay new hues.

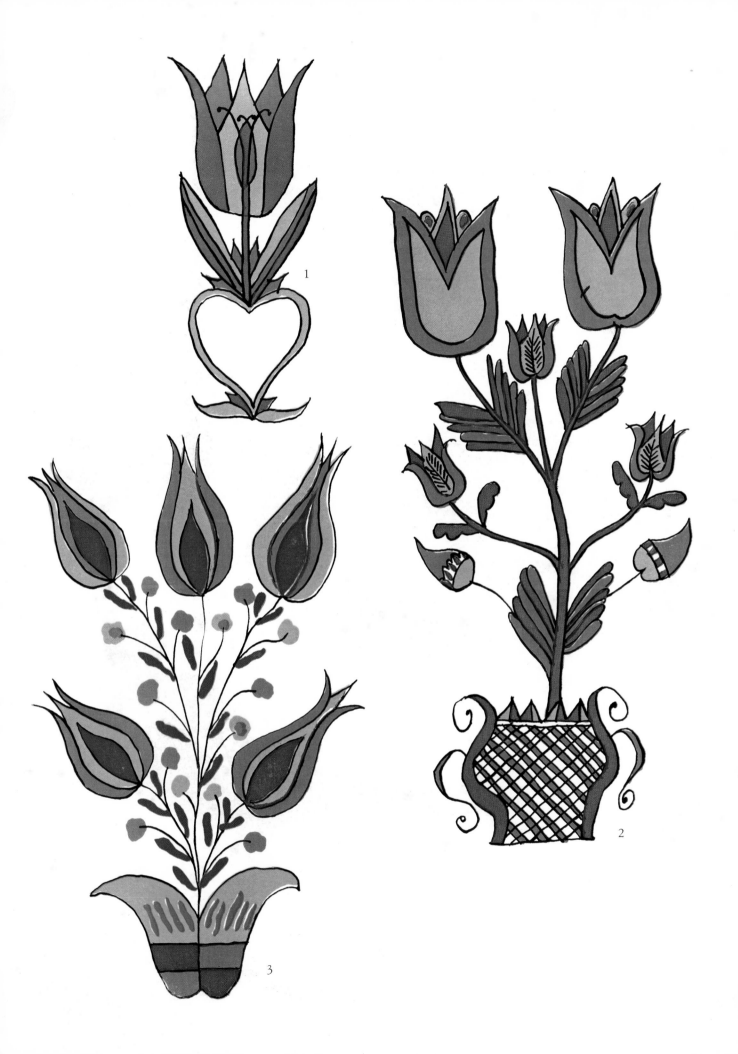

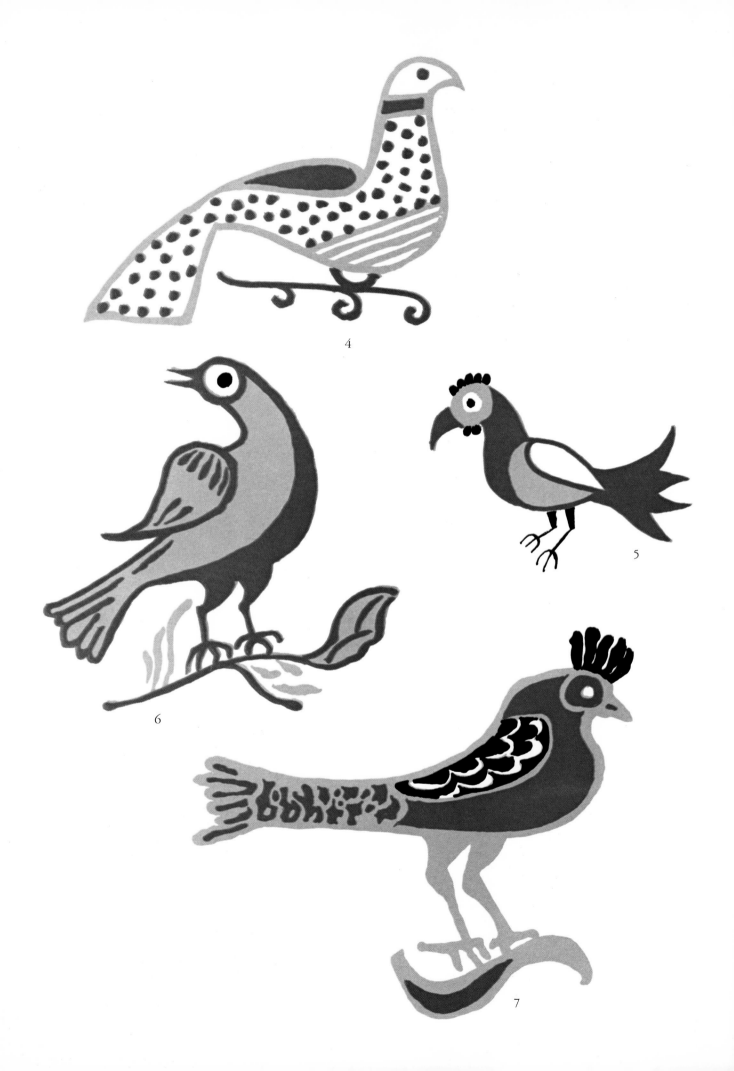

4

5

6

7

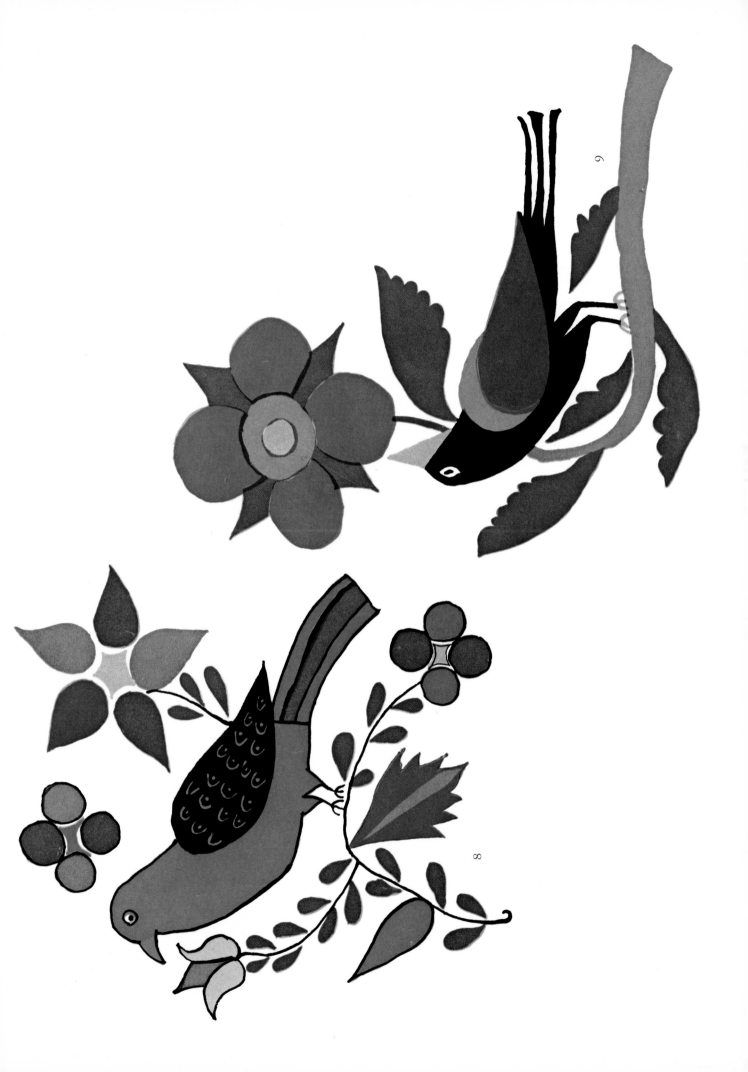

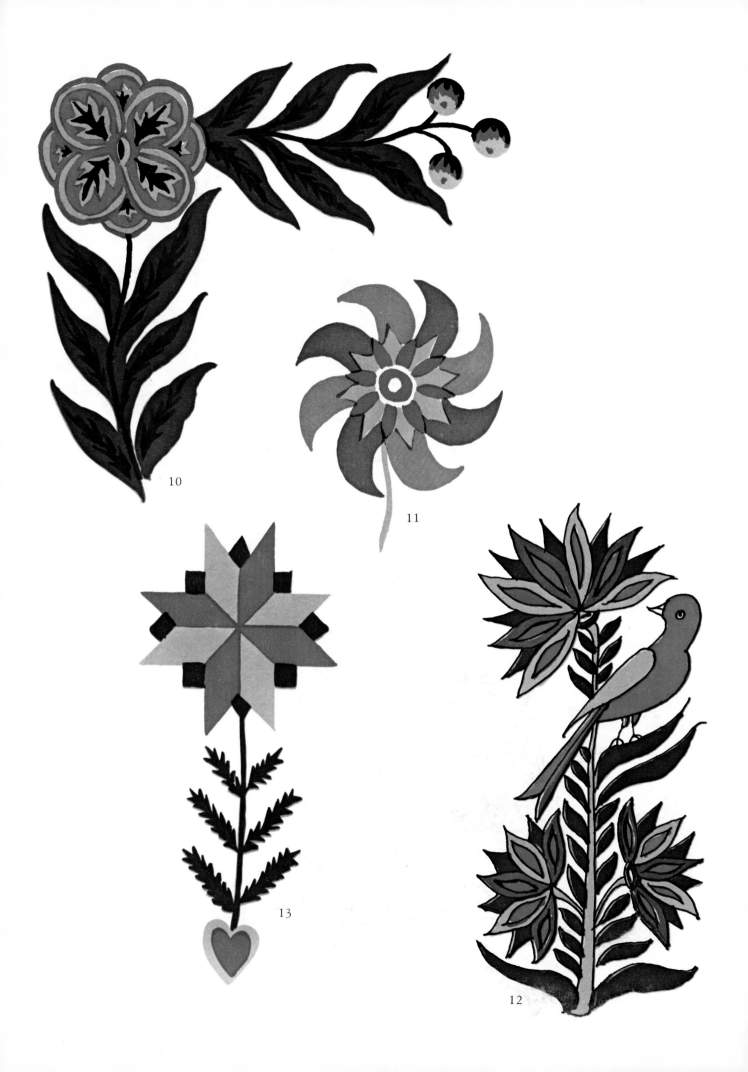

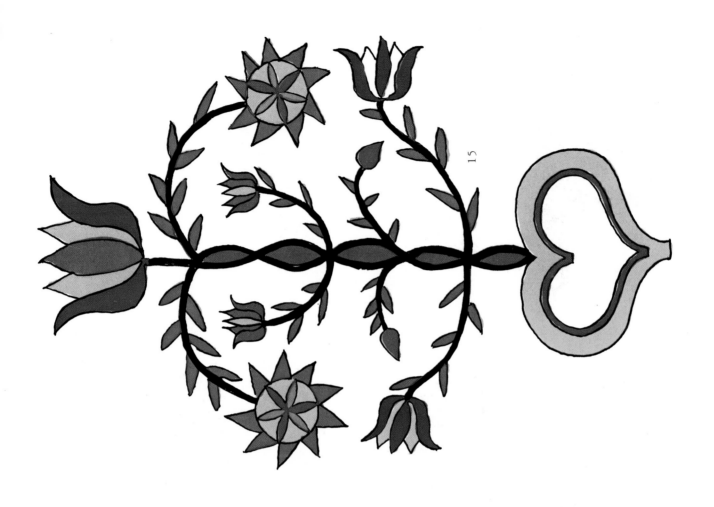

15

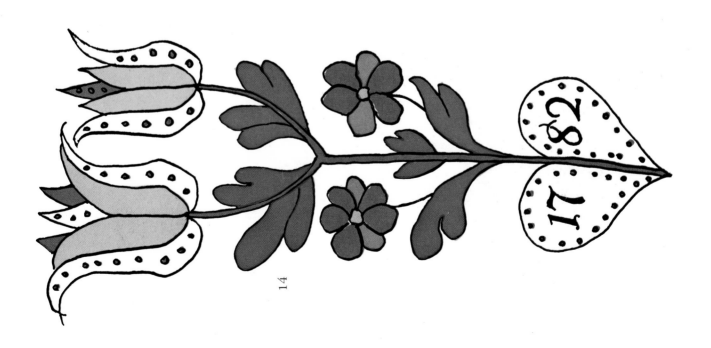

14

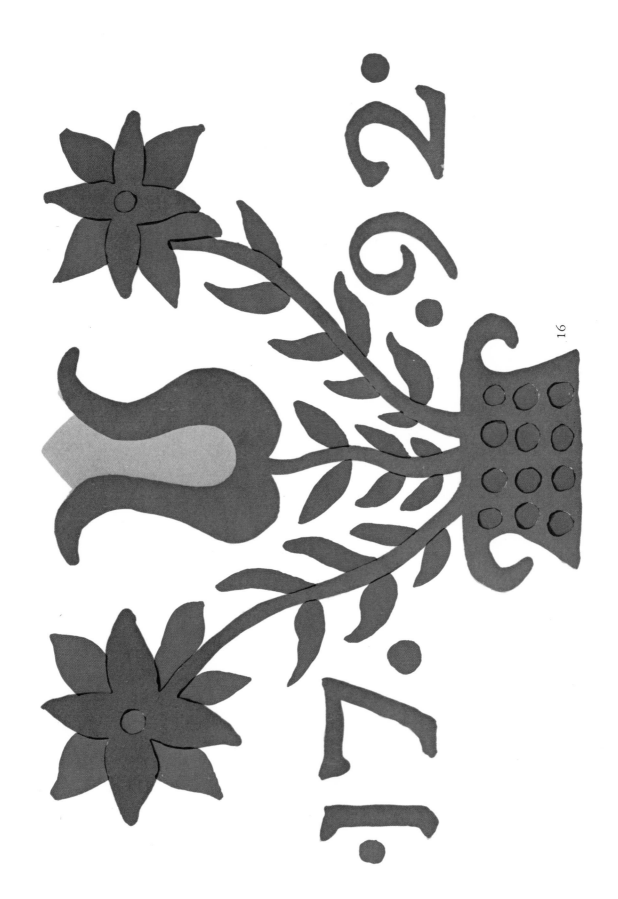

16

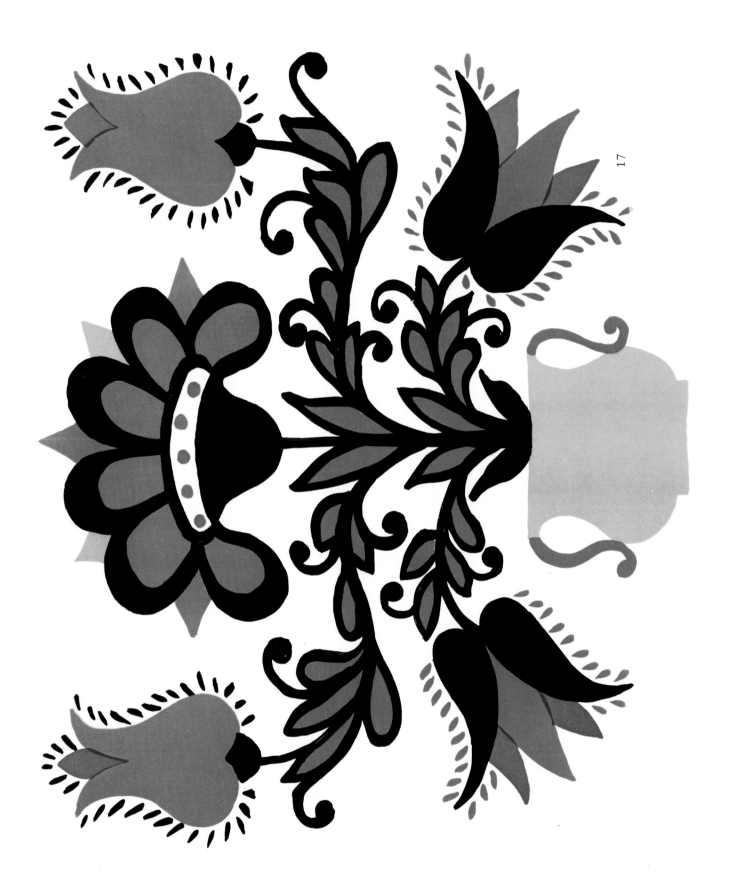

17

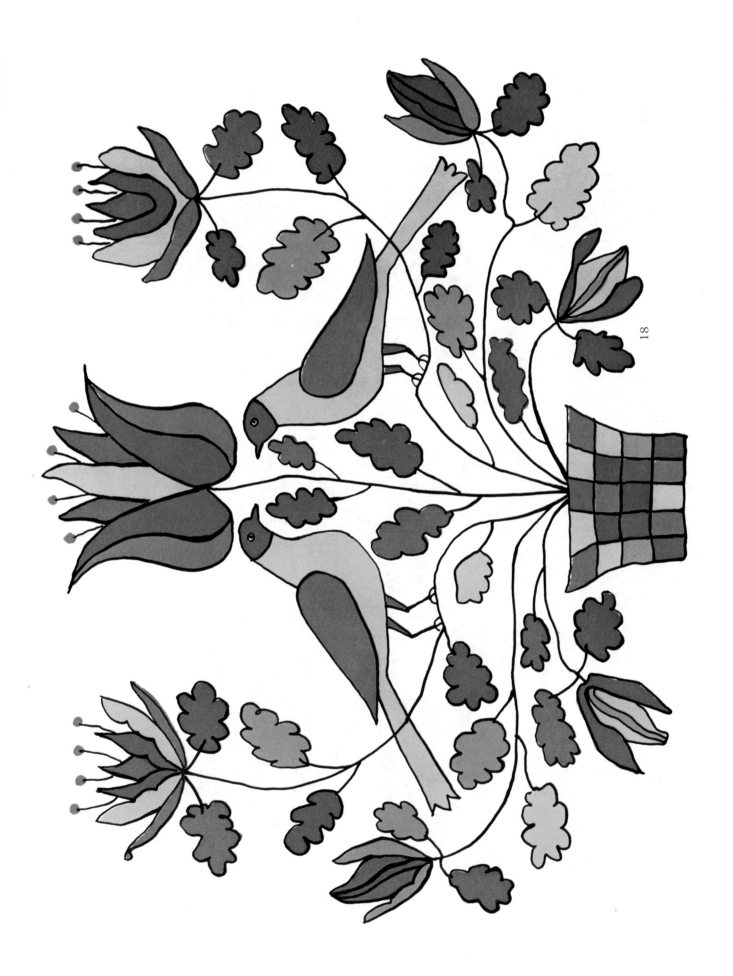

18

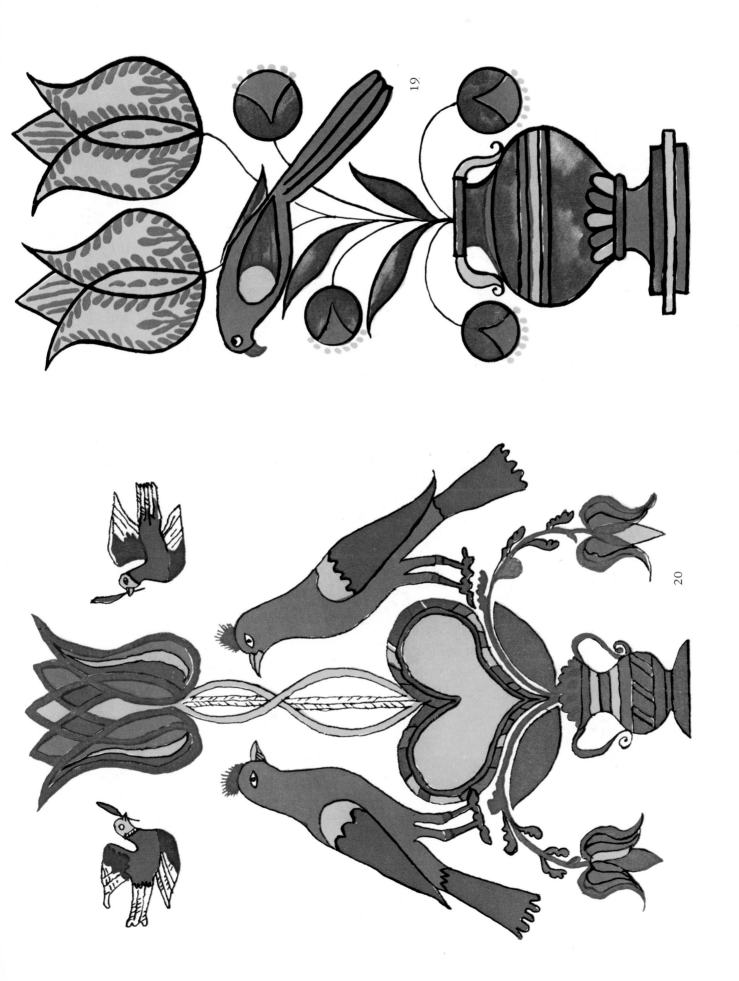

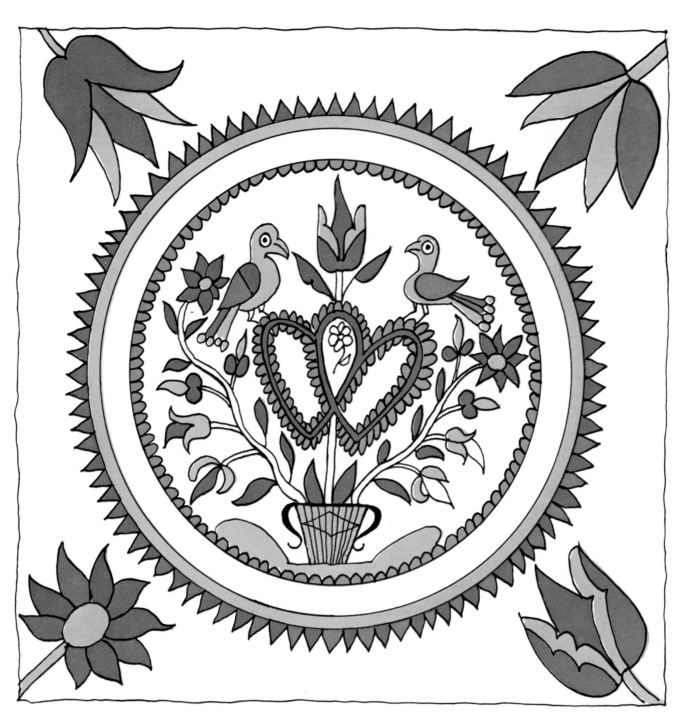

21

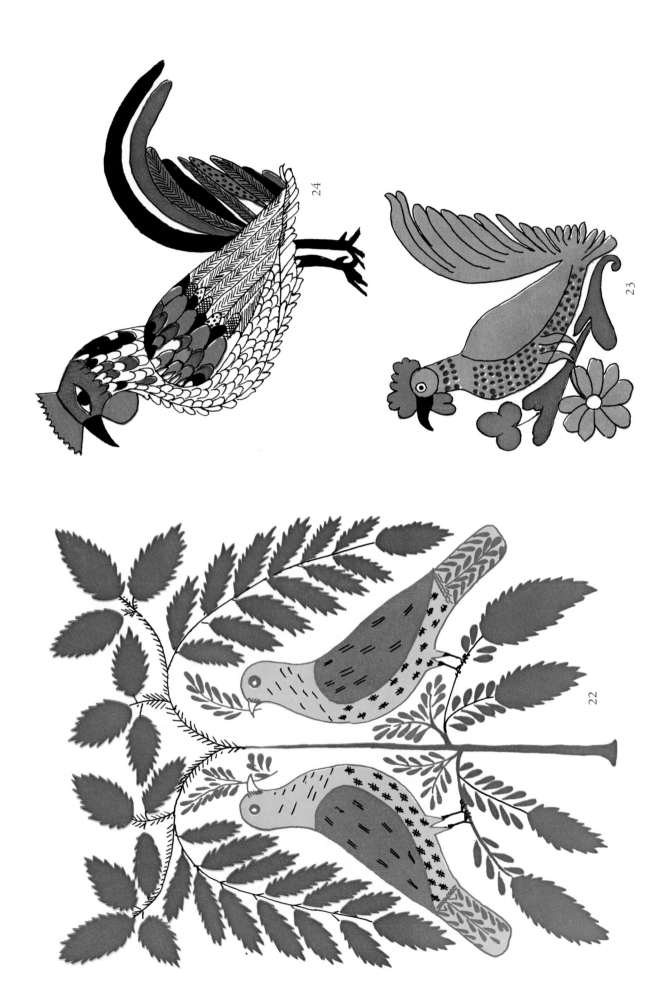

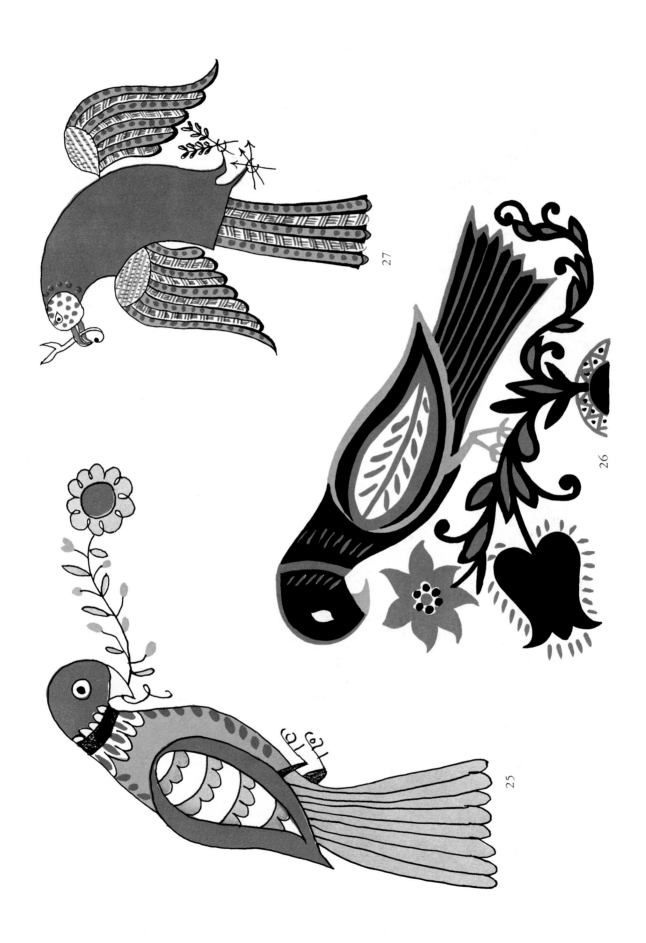

25

26

27

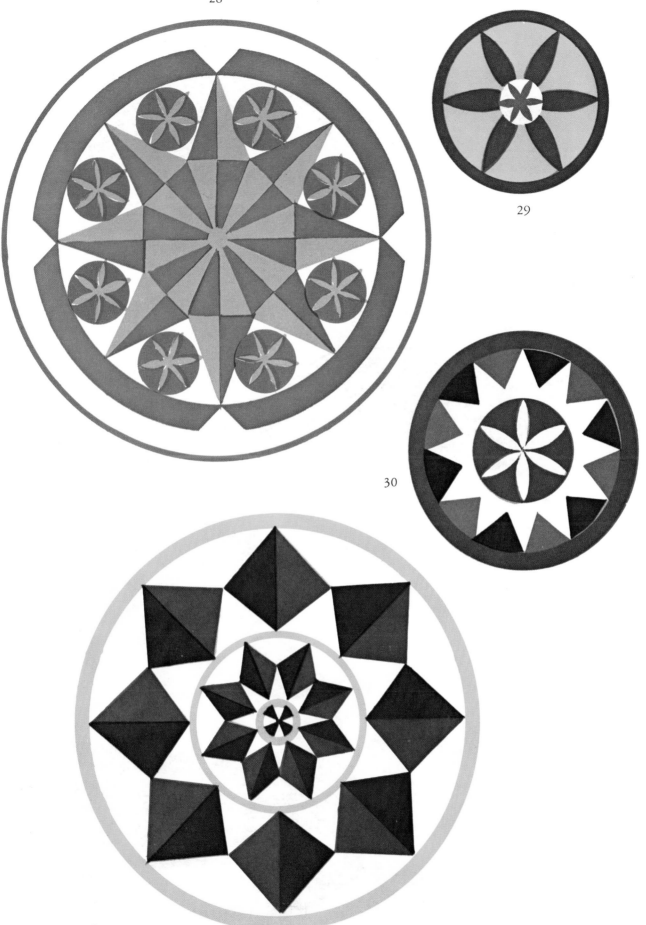

28

29

30

31

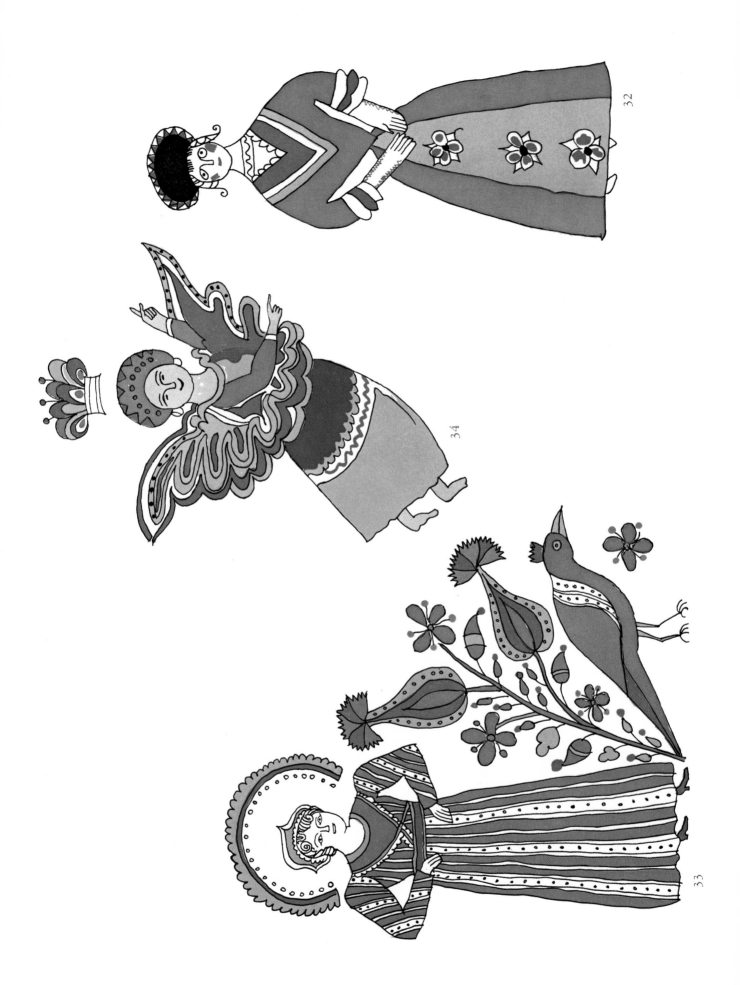

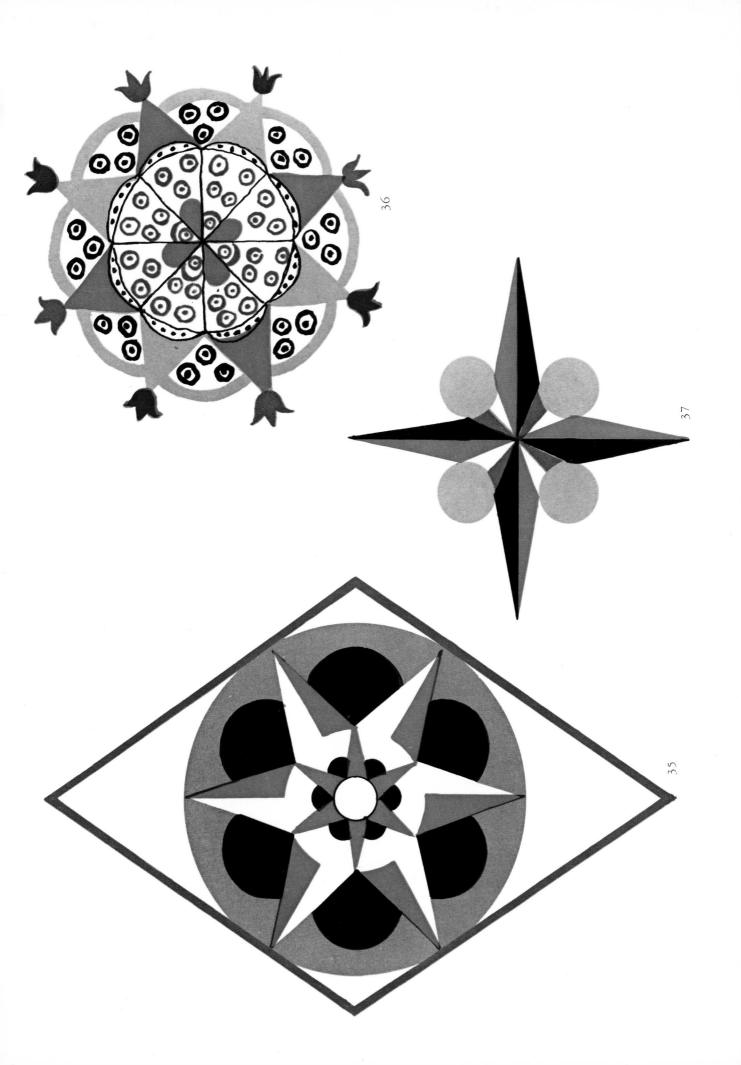

36

37

35

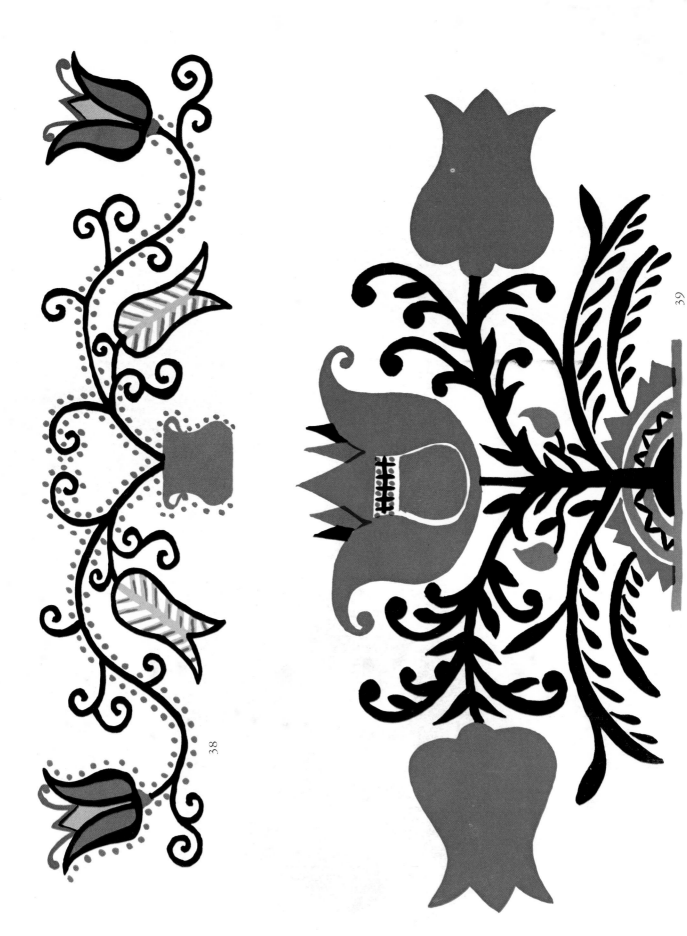

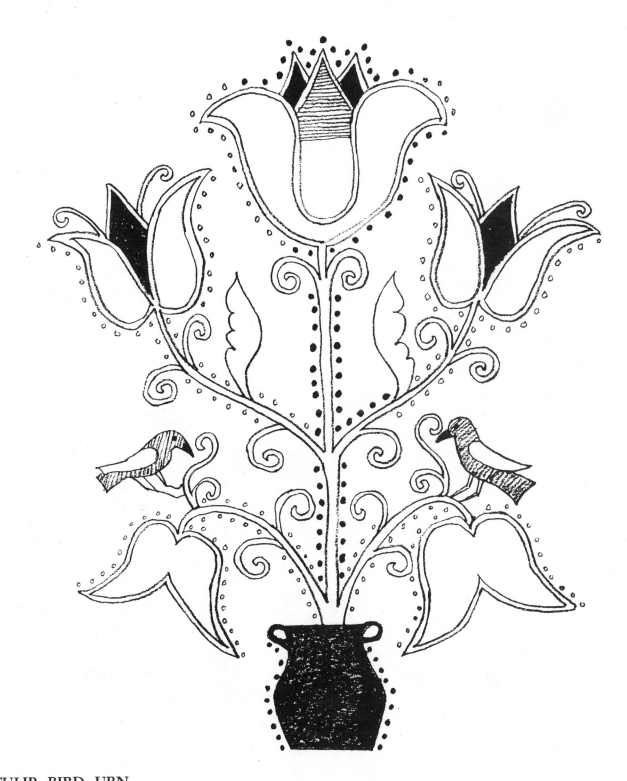

TULIP, BIRD, URN

Diminutive birds add a piquant note to a formally arranged spray of branching tulips. The design was painted in red, yellow, black and white on a dower chest first coated a dark green. The dotted outlines, of which some portions are in red, others in white, are a simple means of providing a touch of elaboration with but slight effort. In local folk art such dotted outlines were very unusual, even though easily worked and not beyond the capabilities of any one who could hold a brush. The decorator of today will find them an asset, if used with the restraint evinced in this well-balanced composition.

TULIP, BIRD, HEART

This motif is unusual on two counts: first, because it is asymmetrical in arrangement, but a balanced effect was achieved by using the motif in reverse on the opposite side of a heart placed in the center of a birth certificate; second, because the bird is superimposed on the rest of the design (see Color Illus. 19, also). Such a treatment, where one unit of a design encroaches upon the area allotted to another, was rarely ever attempted by the folk artist. Ordinarily he avoided the problems of perspective and worked instead in the manner of all primitive people; that is to say, his work was flat, without any shading or suggestion of volume, and followed the tradition of conventional design in which each element was given its own inviolate space.

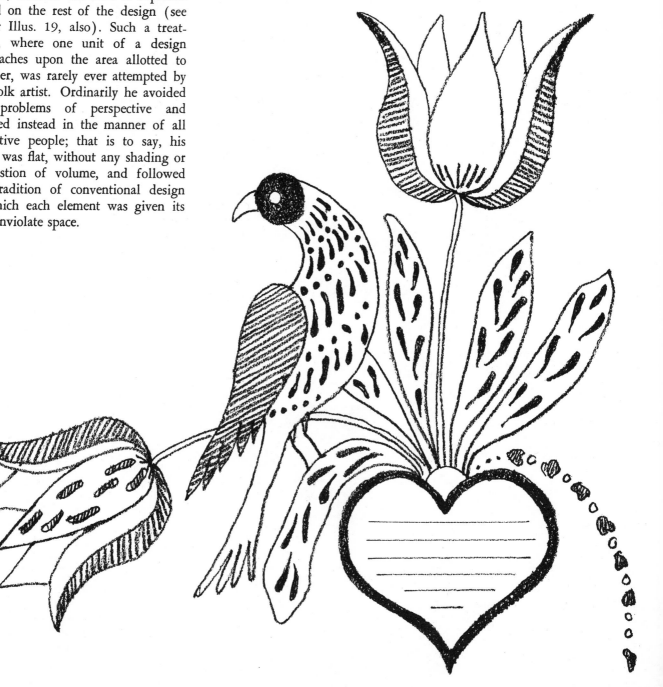

UNTRADITIONAL INFLUENCES

As the United States developed, even the conservative Pennsylvania German craftsman could not remain wholly untouched by outside influences. In the first decades of the 19th century his work began to show traces of the period decoration fashionable during the previous quarter century. Although quite out of keeping with the boldness of his traditional motifs, he adopted these ideas, used them as he saw fit and without constraint. Among the incongruous features he took over were certain ornamental details high in favor during the Empire period. For example, he sketched the great looped draperies of this period as a frame around the standard information he inscribed on the birth certificates, or used them to border the edge of a sgraffito plate, reserving the center for his accustomed tulips and birds.

On chests and other pieces of furniture he often added inlays of delicate laurel leaves or clumsily drawn rococo scrolls to his usual motifs. At this time, too, he used the symbols of the Romantic period—the classic column, bow-knot, rose, forget-me-not, and wreath. Though commonplace all over Europe, these were definitely aliens in rural Pennsylvania. Late arrivals from overseas undoubtedly introduced these originally French devices to local artisans' circles.

An additional reason for the appearance of these romantic decorative devices in the country artisan's work may have been the presence, in the heart of the Pennsylvania German region, of two Moravian Young Ladies' Seminaries, one at Bethlehem and another at Lititz, Pa. Both were well known from early days as educational centers, and taught the refinements and elegancies of the day to girls of good families. Later on as certain farmers became prosperous, they, too, sent their daughters to these schools. In those days all young ladies were instructed in the gentler forms of painting as part of their education. In consequence, the results of their efforts, upon their return to the farm, may have had some slight effect in altering the strongly entrenched folk art patterns of the artisans in their respective communities.

But of far greater importance in changing traditional decorative themes was the fact that, by the time the Victorian period was in full flower, there was no longer any demand for the folk artist's untutored work. If he made any attempt to continue to paint after the 1840's he was obliged to change his style. It was then that he conformed unreservedly to the Victorian idiom in decoration. The motif on the following page is indicative of the manner in which the Victorian rose and rosebud were given the places once held by the tulip. But even such forcible grafting of the symbol of Victorian refinement has not completely obliterated the intrinsic folk quality. The birds are of the familiar peasant variety and the roses are an example of the triumph of peasant love of color over Victorian delicacy; combined in each blossom are petals of blue, orange, lemon yellow, and deep pink. The calyces of the rosebuds are deep olive, the leaves a bright medium green.

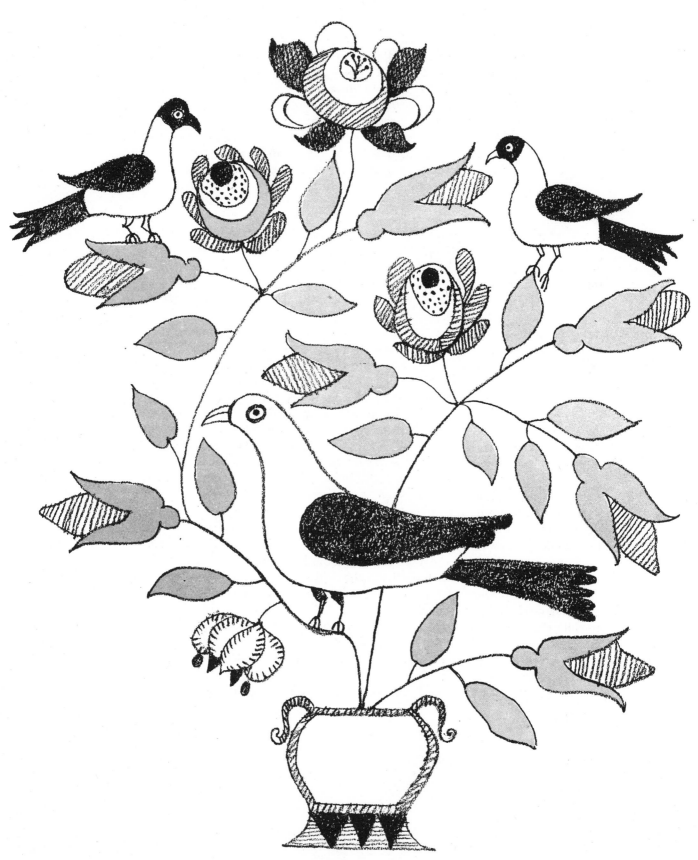

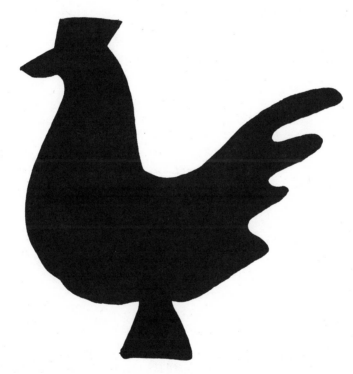

THE COCK (See also Color Illus. 23 & 24)

THE DOVE

In ancient Cyprus doves were sacred birds, the symbol of Venus. All through the ages we find the dove used in decorating, even centuries after its symbolic association with the goddess has been forgotten except by the few. *(See Color Illus. 22)*

THE PARROT

Unlike most birds which the rural craftsman drew, the parrot can always be identified. Even in the crudest of drawings his distinctive characteristics can scarcely be

effaced. The parrot was a favorite of the local fractur scriveners, many of whom seem to have taken for their models the parrots which first appeared on the woodcut birth-and-baptismal records printed by Heinrich Otto, an outstanding 18th-century folk artist of Lancaster County in Pennsylvania.

A parrot known as the Carolina parakeet was once an everyday sight in Pennsylvania. Today it is no longer seen. With its grass-green body and bright red head, it never failed to attract the attention of early European visitors here, who published accounts of it upon their return to their homelands. *(See Color Illus. 25 & 26)*

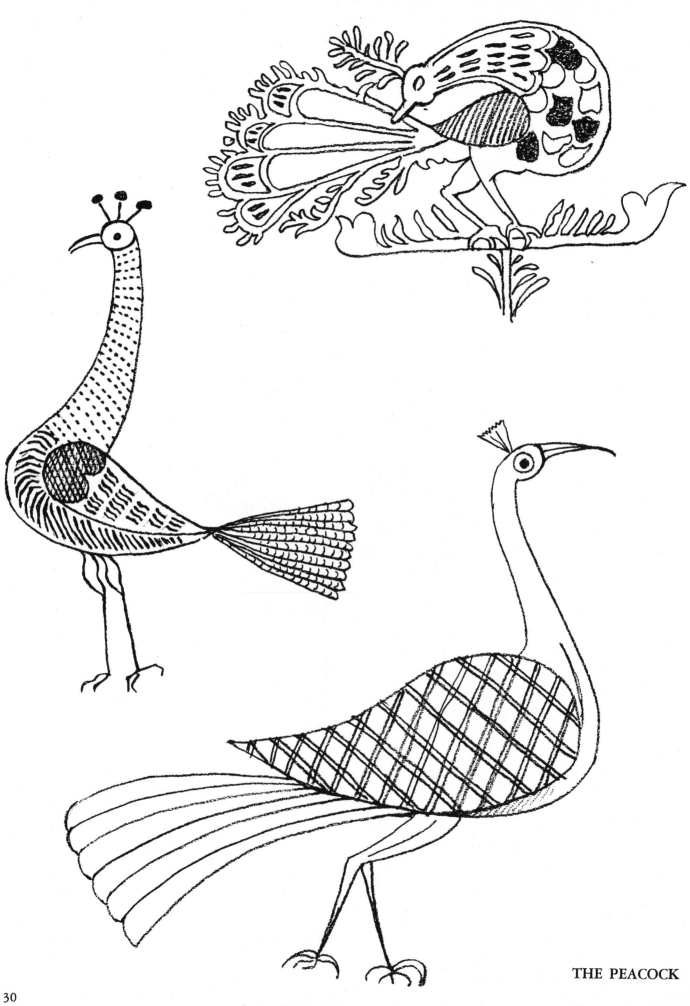

THE PEACOCK

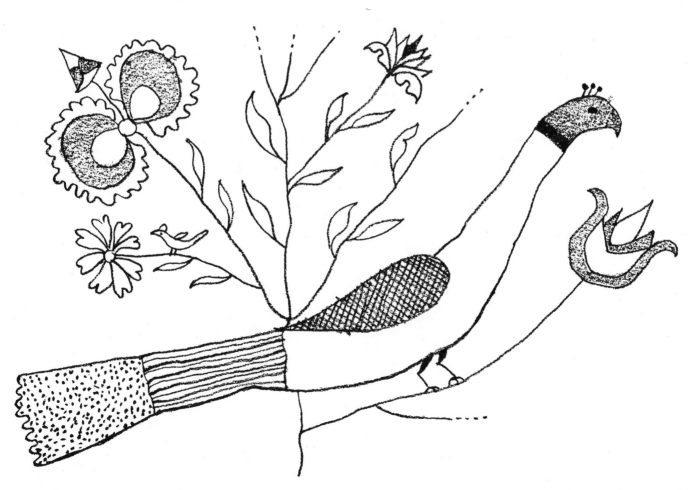

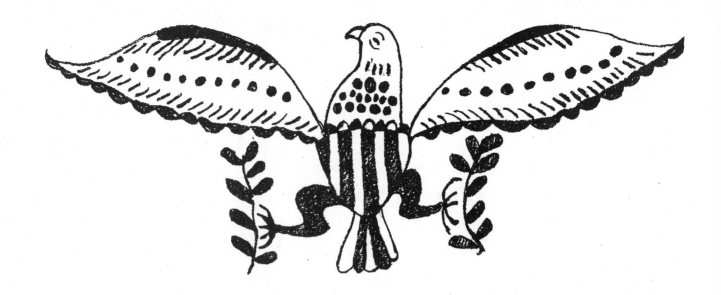

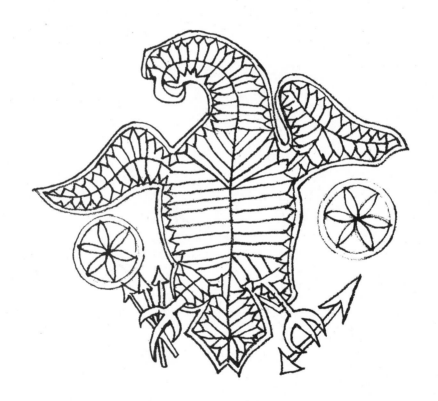

THE EAGLE

So naïvely humorous are the folk artist's interpretations of the eagle—the emblem of the United States—that one needs a tolerant eye to accept them. Rarely is the eagle depicted in a natural attitude; instead, the craftsman showed a distinct preference for the stylized version of the bird, fronted with shield, his talons in a bundle of arrows and/or olive branch.

As the eagle was the most popular patriotic symbol after the Revolution, there was no lack of woodcuts picturing it. Drawing inspiration from these woodcuts, the folk artist adopted the symbol with gusto. Eagles spread their wings on pottery, screamed on birth certificates, were painted on dower chests and shaped in tin as cookie cutters. Women even appliquéd large eagles on quilts. The eagle was also a favorite choice of the carver of buttermolds (lower) since the technique of woodcarving lent itself excellently to the portrayal of plumage. (*See also Color Illus. 27*)

32

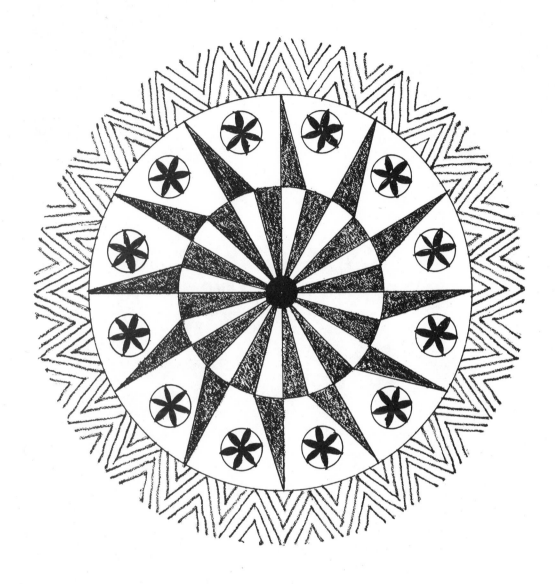

THE BARN SYMBOL

Only in Pennsylvania does the barn make pretension to anything but utility. Here, in certain Pennsylvania German sections of the state, the barns are not only as useful as those elsewhere, but strikingly decorative as well. This ornamental quality is derived from circular ornaments of considerable size painted on both the front and ends of the barn. From three to seven is the usual number of these colorful ornaments, which usually show some kind of star within the circumference of a circle. Many of these designs are very simple. Others are so elaborate in their geometric divisions and subdivisions that they seem almost to be exercises in the ingenious use of the compass and straight edge.

In certain counties, a half-century ago, almost every barn bore these brightly painted disks, but through the years the number of decorated barns has been diminishing. Today, those who still keep up this custom say they do so because they like to see these great wheels which add so much interest to the barn's dull red. It is thought by some that these wheels in early days served as a symbol to protect the barn and stock from witchcraft and lightning. Hence the recently popular name of "hex marks," a term to which too much emphasis has been given without sufficient documentation. *(See also Color Illus. 28–31)*

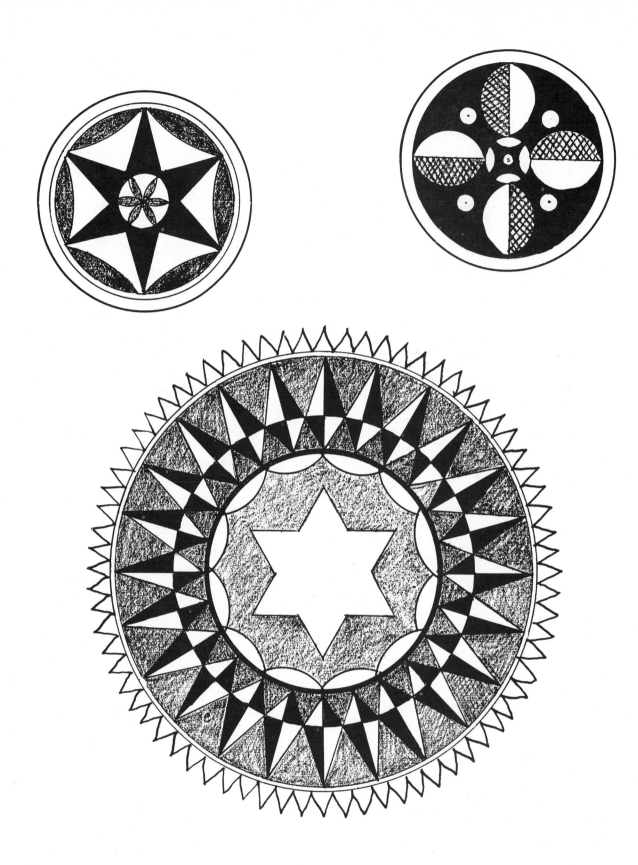

THE BARN SYMBOL

The device of a star—whether with four, five, six, eight, or more points—is a very old symbol, linked by archaeologists with a cult of the sun. It is said also to have a connection with the idea of fertility. Since peasant art is a repository for ancient values it is not at all surprising to find that the Pennsylvania German farmer adhered to this very old symbol, using it on his barn and utensils exactly as did his forebears overseas. Even today these symbols can be found on the gates and houses of European peasants in certain districts.

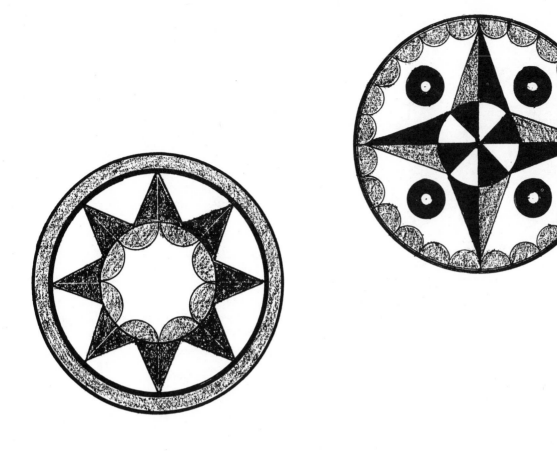

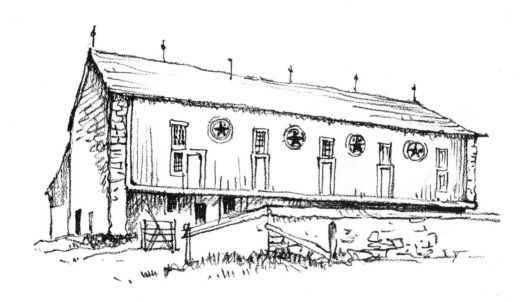

THE BARN SYMBOL

Color Illus. 28: This impressive decoration on a barn is the center one of a group of five, the others, in pairs, being less elaborate. Barn decorations seem not to have been used prior to 1850. As they were tedious to repaint, they were often effaced when the barn received a fresh coat of paint. In this instance, however, the ornaments have been kept up whenever the place was refurbished.

As this particular farm is far from main-traveled roads, there can be no question that the decoration was lavished on the barn not to delight the passerby, but the owners. This is heart-warming evidence that the folk love of design has not yet been wholly extinguished even in this day of practical asbestos shingles and aluminum roofing.

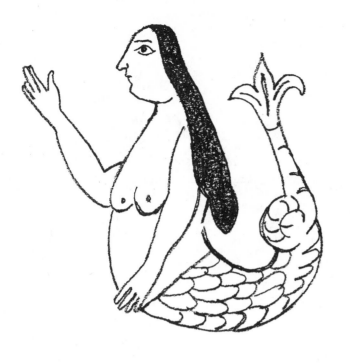

THE MERMAID, THE FISH

It is not surprising to find the mermaid of legend among the motifs used in Pennsylvania German ornamentation as the mermaid, half-human, half-fish, was a favorite subject of craftsmen in Europe. There, mermaids were carved in wood, hammered in brass or cut in stone. Here the craftsman employed them primarily as a decoration on birth certificates, moved perhaps by the ornamental possibilities in the curving lines of body and tail. With quill pen he drew the mermaid in an intensely naïve manner, in conjunction with those motifs of which he was so fond —the tulips, hearts and nameless floral forms. Except for a few mermaids painted on chests, or scratched on pottery, this use of the motif seems to have been limited in local folk art to the fractur writers.

Lower left: One of a pair, this mermaid flanking a tulip has been viewed as sheer ornament. The semi-human aspect is obliterated by a startling grotesque face (almost fish-like) with an elaborately patterned body and florally decorated tail.

Opposite page: Fish, actual denizens of the sea, were also used occasionally. They were an important Christian symbol standing for the Savior. In this motif, taken from a chest of quite early date, we find two fish incongruously arranged with the stiffest of urn-supported tulips. While fish are ordinarily placed in a formal arrangement, in this case they are snapping at insects—an unusual touch of realism.

Upper left: An equally grotesque drawing with more usual treatment of scales and tail.

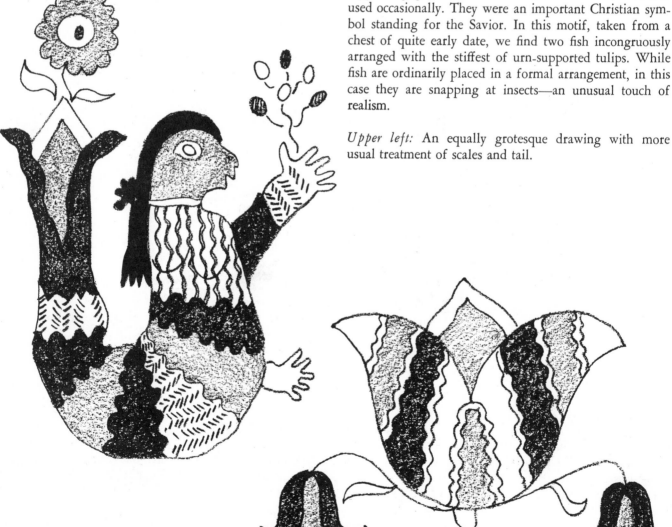

36

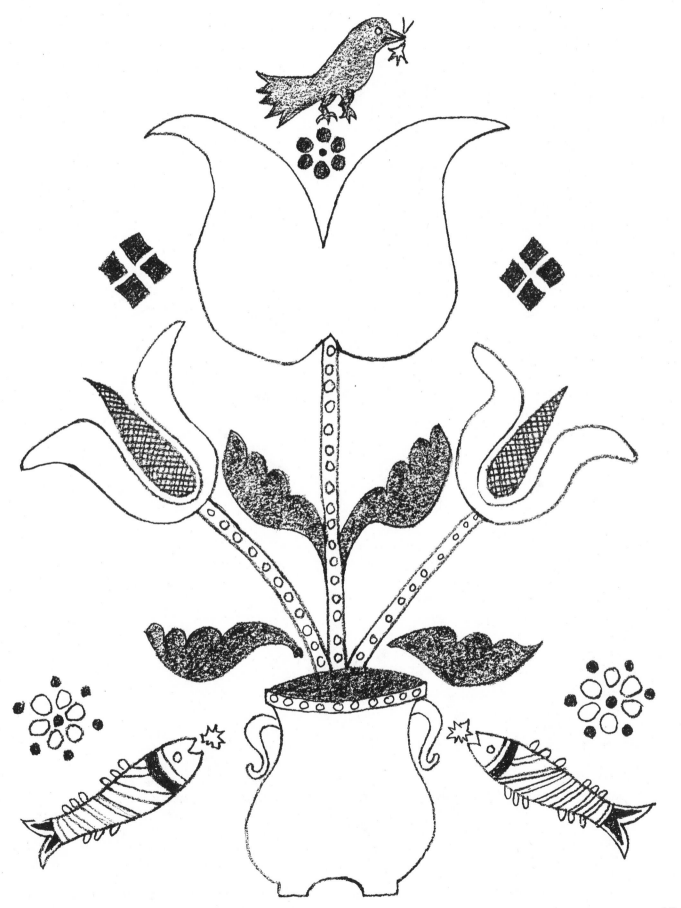

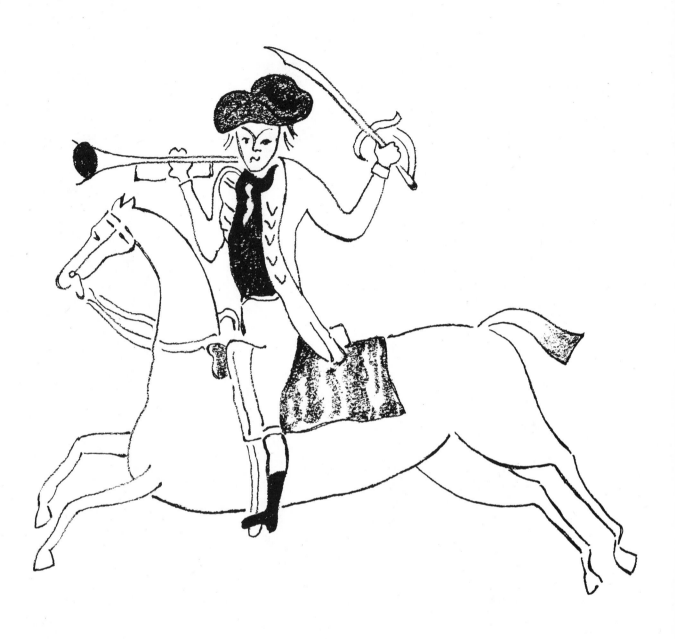

THE HUMAN FIGURE

The problems of an adequate portrayal of the human figure were usually beyond the abilities of the folk artist, who had received no conventional artistic training, so that he rarely attempted it. When he did, the results were often grotesque, more often amusing. Primarily used as decorative elements on birth-and-baptismal certificates, human figures were a stimulating addition to his usual birds, hearts, and tulips. Color Illus. 32, drawn in 1766, is dressed in the fashion of the 18th century, but we shall frequently find the ladies on certificates, drawn decades later, wearing costumes of the same period. Such steadfast adherence to outmoded styles can be explained by the fact that 19th-century fractur artists often traced the figures their predecessors had drawn, instead of inventing new ones more suited to the times.

Once in a while, however, a fractur artist, more ambitious than his fellows, attempted to clothe his figures in garments which reflected current modes. The costume in Color Illus. 33 is that of the early 19th century, the period in which the drawing actually was made. All of its details reveal the radical change which the Empire period introduced into fashion. Here we see the short bodice and narrow striped skirt, a style which remained in high favor all through the first several decades of the past century.

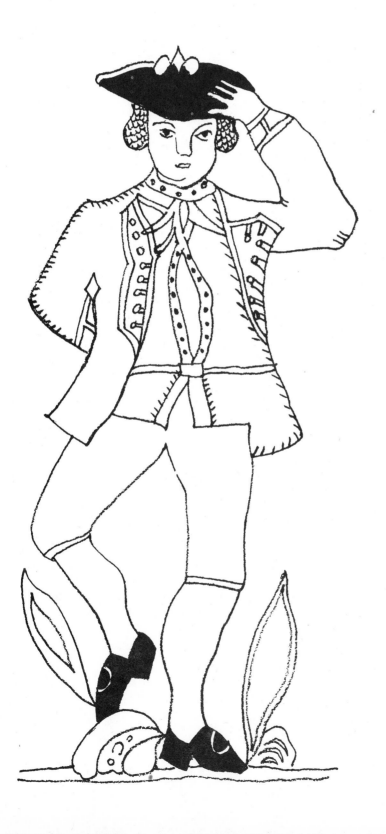

THE SOLDIER, THE HORSEMAN

After the Revolution the motif of the Continental soldier was added by the Pennsylvania potters to their repertoire of patterns for ceramic plates. These designs of soldiers brought a new note to their product and no doubt had considerable popular appeal, especially to customers who had known similar designs in their homelands. The European potter had long found the mounted cavalier, with upraised sword, an attractive subject. Local potters found that it took only slight alterations in costume to transform the mounted cavalier into a patriotic American figure.

Except for a few dower chests, the horseman was used almost entirely on pottery plates. But the foot soldier was not overlooked entirely either for he, too, was pictured in this medium. Aside from these examples, both in earthenware, the military motif was ignored by the folk artisans given to decorating their work. Soldiers were practically never a design chosen by the fractur artist, except for the example to the left, which was taken from a birth certificate. However, this might as easily be a drawing of a civilian as of a soldier.

While another artisan, the tinsmith, turned out an occasional large cookie cutter which represented a soldier on horseback, the cutter and the cookies it stamped out were but a feeble approximation to the intricately modeled gingerbread molds and their sightly product which delighted generations of European children. But children are not too critical and undoubtedly Pennsylvania youngsters derived as much pleasure from these primitively shaped horses and their riders as did their counterparts on the other side of the ocean from their fancy gingerbread men.

HEAVENLY SYMBOLS: THE ANGEL,
THE CROWN

Color Illus. 34: This angel is taken from a birth-and-baptismal certificate. In spite of its archaic quality, it is recognizable at once as a celestial figure; there are others, however, on similar documents which are barely identifiable as divine symbols, so shapeless are they. In spite of their lack of form they are nevertheless all direct descendants of an honorable line of beauteous beings: the angels hovering over the manger in countless scenes of the Nativity which have been painted by the great artists of the world. In the folk artist's memory, images of these religious paintings must have been retained, to be recalled when he needed them. While his lack of professional draughtsmanship often reduced the angels to mere cartoons, on these papers which recorded the important religious ceremony of baptism, they were still appropriate symbols of heavenly guidance. Here the angels watch over the welfare of the humblest Pennsylvania German child just as do the angels in the great Nativity paintings. In addition they usually point a finger upwards, admonishing their charges in the way they should go.

Opposite page: The figure of the angel painted on a chest of drawers bears witness to the fact that styles in costuming, even for heavenly beings, were subject to fashion's whims. By the early 19th century the pairs of angels used on the everyday printed birth certificates no longer fluttered in the sky in Renaissance garb, but stood erect in the severe costume of the Empire period. When certain furniture decorators needed a human figure, they turned to these stiff figures on the certificates and traced them. The result was to transform the woodcut angel of the certificates, already quaint, into something even more stylized than before.

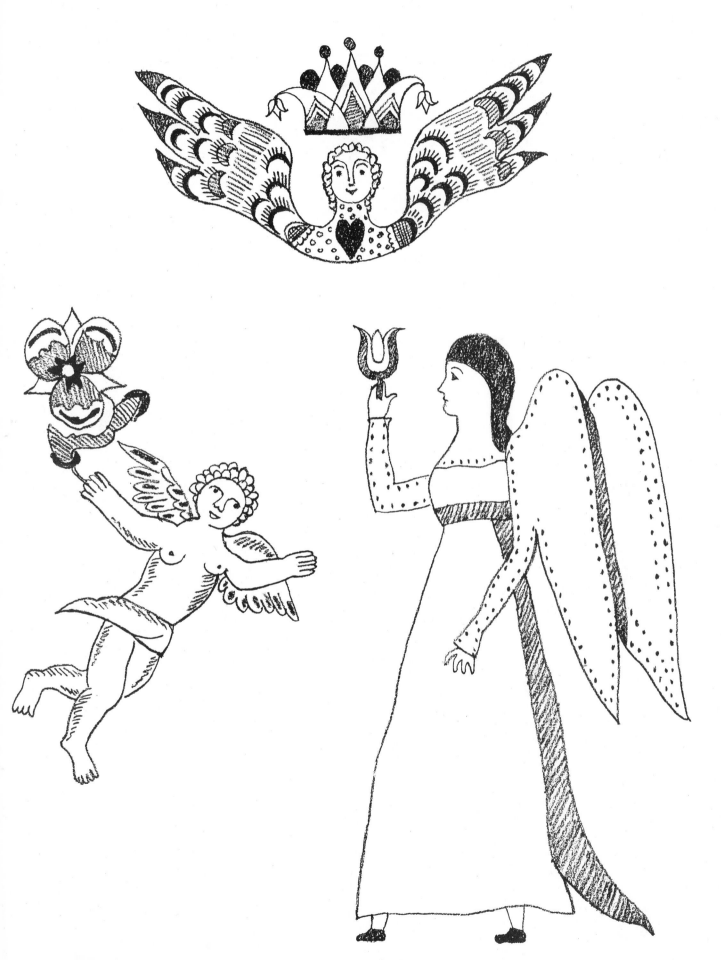

41

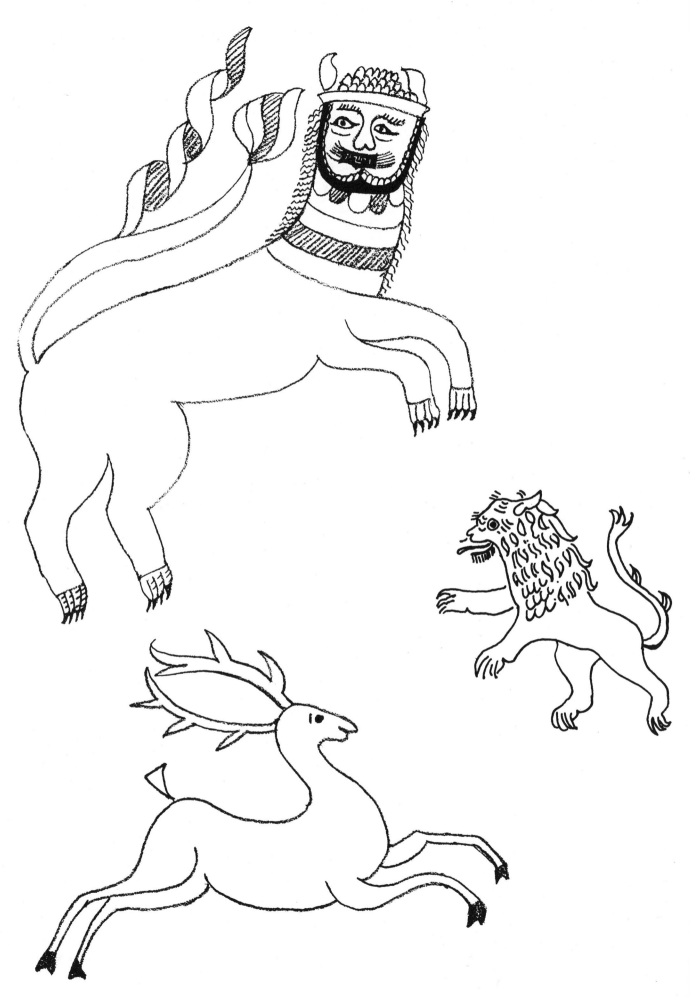

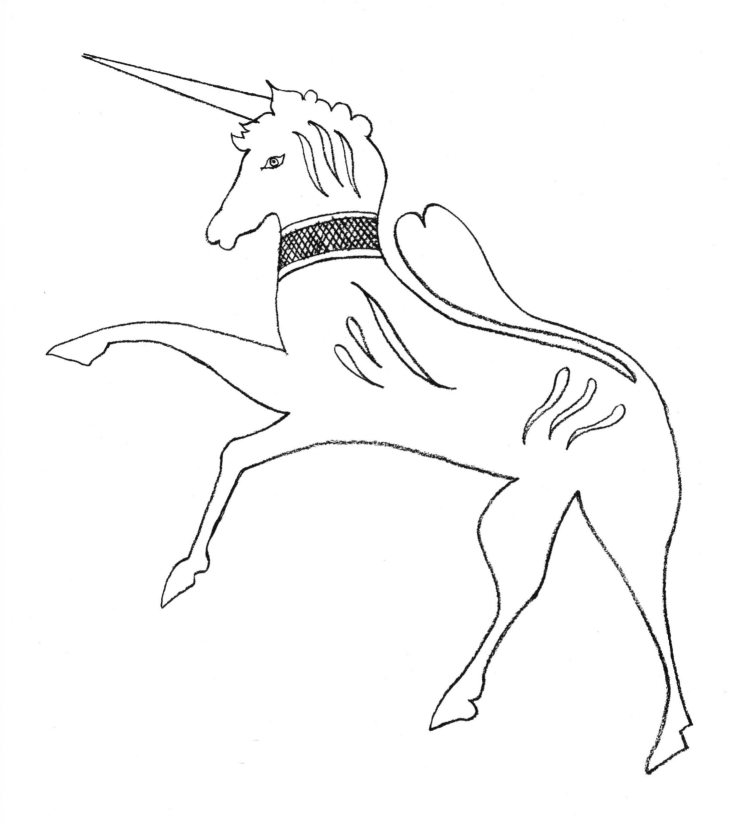

THE HERALDIC ANIMAL

The European folk artist found heraldic animals of use in many kinds of decorative schemes. So did the Pennsylvania German, and, on his part, with an engaging disregard of the rules of heraldry. He did not place his unicorns or lions as supporters to a shield on a coat of arms, as one might expect; instead, the hoofs or paws of his flanking beasts are used to brace a formal spray of tulips or a conventional motif. Heraldic animals, notably the unicorn, are a feature of certain dower chests. On these they usually dominate the central panel. The panels flanking the unicorns are filled with characteristic ornament. The Middle Ages regarded the unicorn as the symbol of purity and virtue.

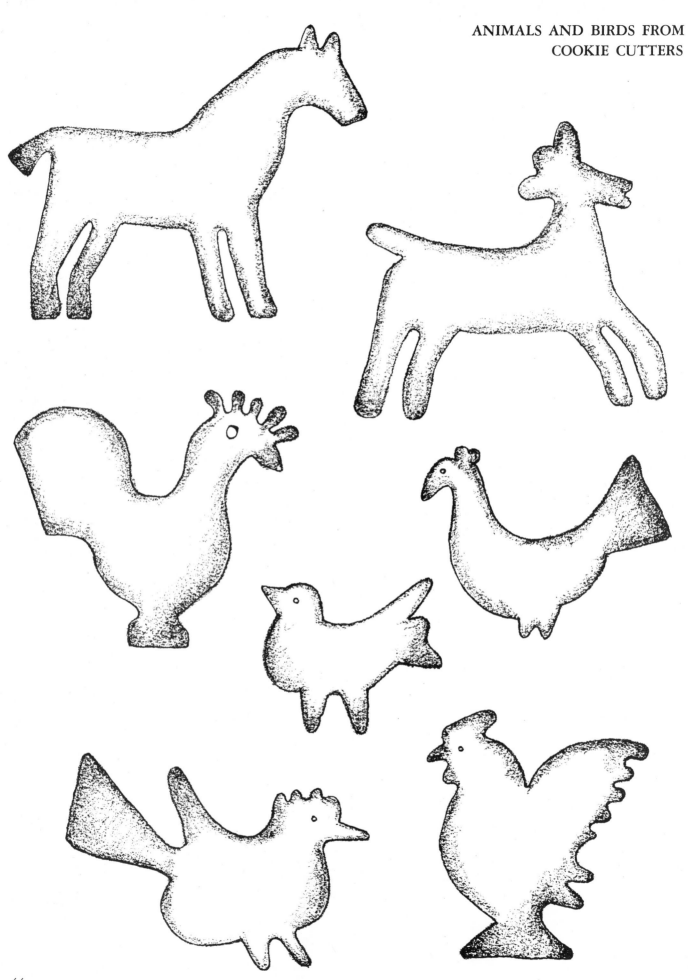

44

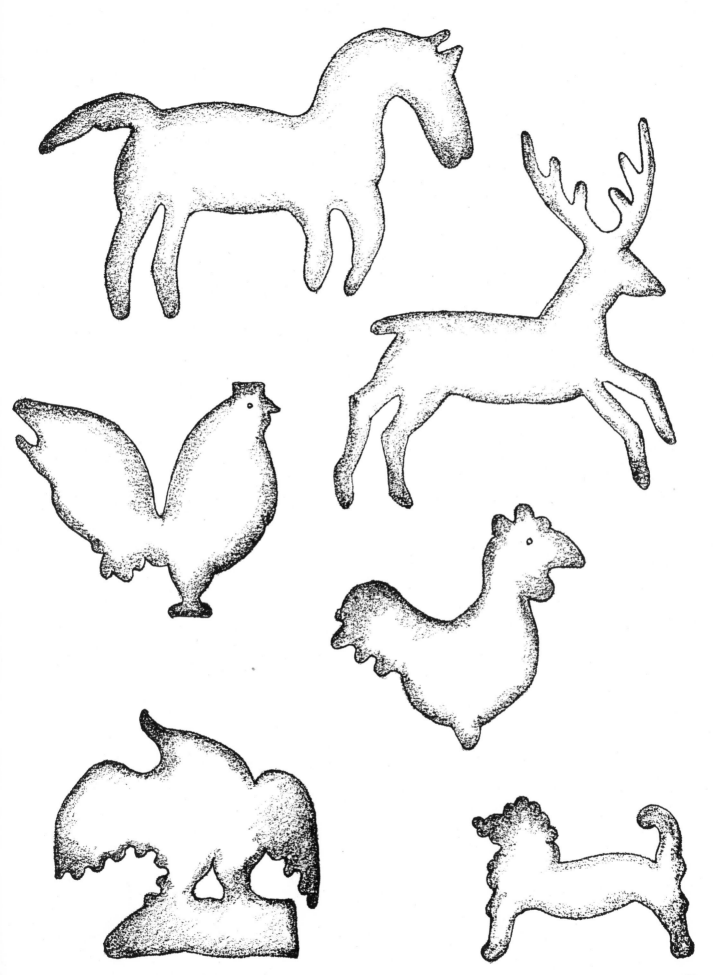

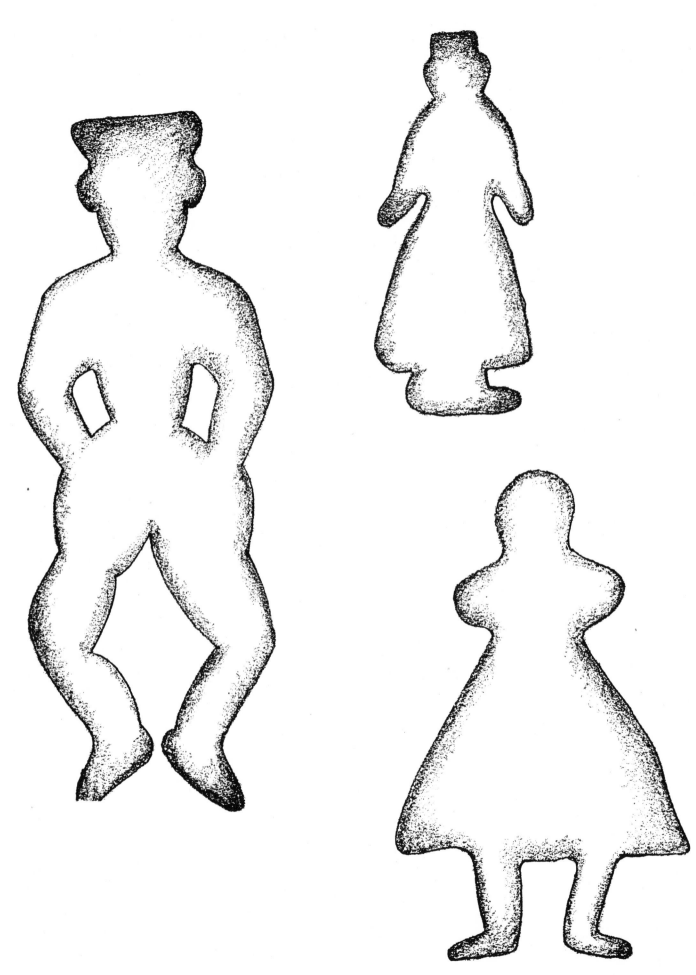

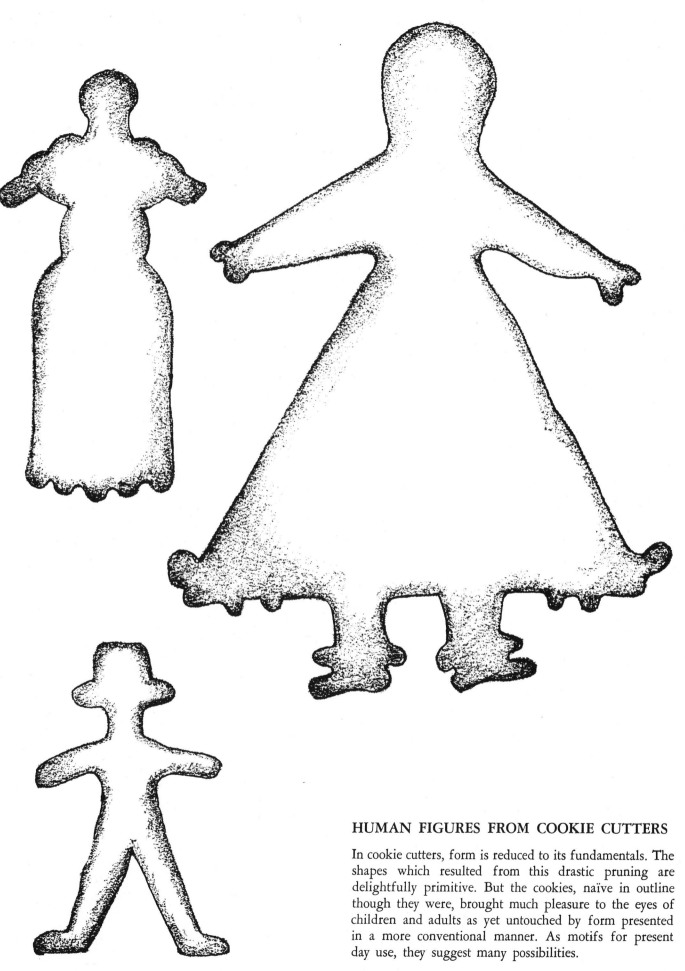

HUMAN FIGURES FROM COOKIE CUTTERS

In cookie cutters, form is reduced to its fundamentals. The shapes which resulted from this drastic pruning are delightfully primitive. But the cookies, naïve in outline though they were, brought much pleasure to the eyes of children and adults as yet untouched by form presented in a more conventional manner. As motifs for present day use, they suggest many possibilities.

WITH COMPASS AND STRAIGHT-EDGE

The straight-edge and compass were of considerable usefulness to those craftsmen who felt an urge to decorate and were not endowed with the particular skill which would enable them to carry out their ideas to their satisfaction in freehand drawing. Though these tools gave a perfection of line, it is apparent that this was not the basic reason why the craftsman used them. They were employed, rather, to obtain certain decorative motifs. One of the most familiar—and one used by every type of craftsman—was the geometric motif known as the barn symbol, or six-pointed star. It can be seen in its most dramatic form painted on barns.

"Barn stars" (the local name for the great geometric symbols which add such distinction to the Pennsylvania German barn) are always executed with mechanical aids, which were indispensable, for only with a huge pair of wooden compasses could one swing the great circles (six feet across) at such a distance from the ground, for the "barn stars" were placed quite far up on the walls. Moreover, these tools were essential to mark out the subdivisions which make up the actual design within the circle, for the circle was invariably filled with geometric patterns. In its plain state the circle has no appeal to the folk, who, once having discovered that the radius always divides the circumference with the same invariable precision, used this simple geometric principle with much pleasure in various phases of their arts. The "barn star" painters, in particular, must have taken an actual delight in their inventiveness in this field, exploring the many possibilities latent in the compass plus straight-edge. Any examination discloses that there are hundreds of variations on the theme of six divisions, besides all those based on four, five, eight, and even twenty-four.

THE LOZENGE

This is a form shown on chests of quite early manufacture (Color Illus. 35–37). Here it is used in combination with a circle, the latter in itself interestingly subdivided. The pomegranate motif (see page 15) when presented in a stylized manner could be laid out with a compass. When the folk artist accompanied this stiff form with freely drawn foliage, he felt no incongruity whatever.

Many ornamental drawings extant display motifs drawn freehand which, nevertheless, were copies from others geometrically planned. In most cases these appear on ornamented manuscripts. But as there are others drawn on small rectangles of paper, with no inscriptions whatever, they must have been made for the sheer pleasure derived from producing something decorative, whether geometrically inspired or not.

MOTIFS EVOLVED THROUGH GEOMETRY: THE HEART

To draw hearts the compass was frequently resorted to. The diagram (at the left) indicates the geometric plan. This produced a very broad heart which we find in the work of craftsmen whose equipment included compasses. Among such were the cabinet maker, decorator of dower chests, and the barn decorator. The latter used a large wooden compass, and with it he planned the great stars on the barn face, and occasionally marked out a heart as an extra flourish. The heart was given a central position in the composition.

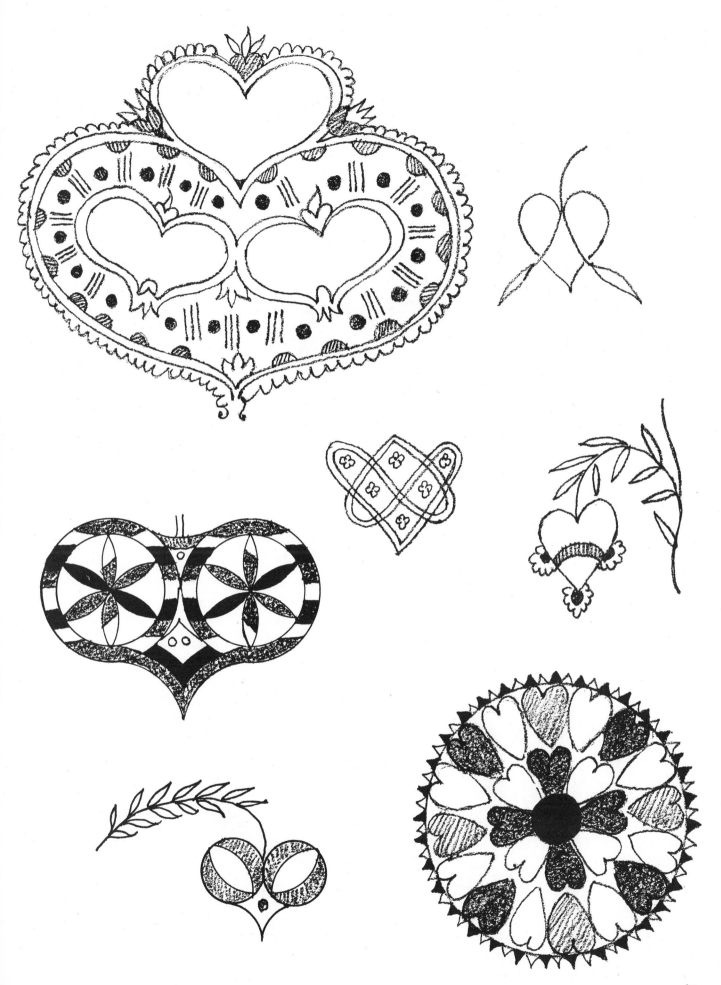

49

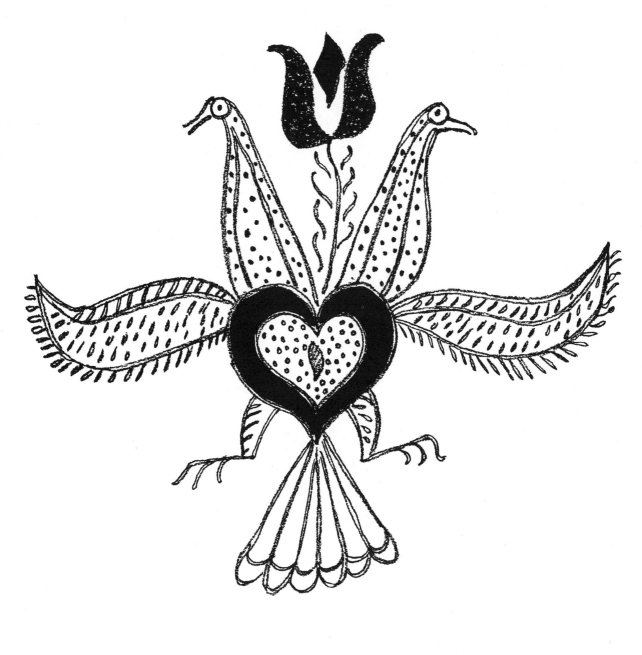

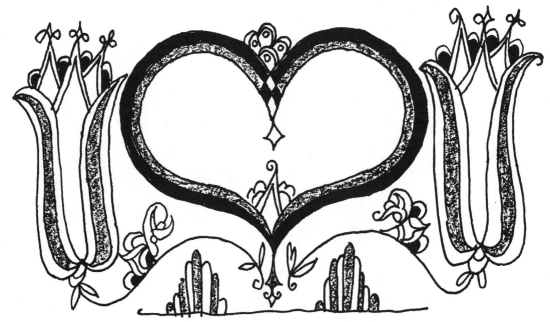

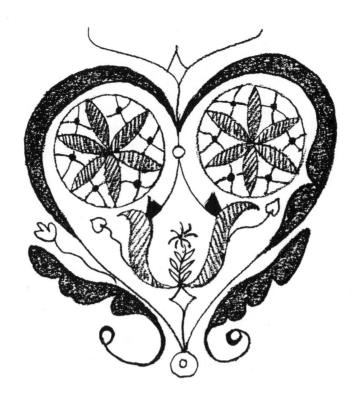

MOTIFS EVOLVED THROUGH GEOMETRY:
THE HEART

If the "fractur writer" (as the illuminator of birth-and-baptismal certificates or *Taufscheine* was known) possessed a compass, he too used it to delineate the heart. It is remarkable how many variations the fractur writer evolved from this simple form. Sometimes he saw it as a pendant blossom; when he used it radiating from a center, it became a rosette. Often he flanked a large heart with tulips; at other times the heart served as body for one of his diverting birds (see opposite page). When hearts were drawn freehand, they frequently follow the curious width of those arrived at by mechanical means.

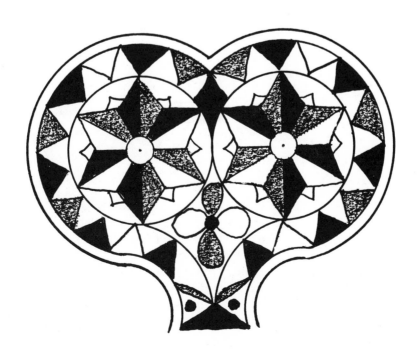

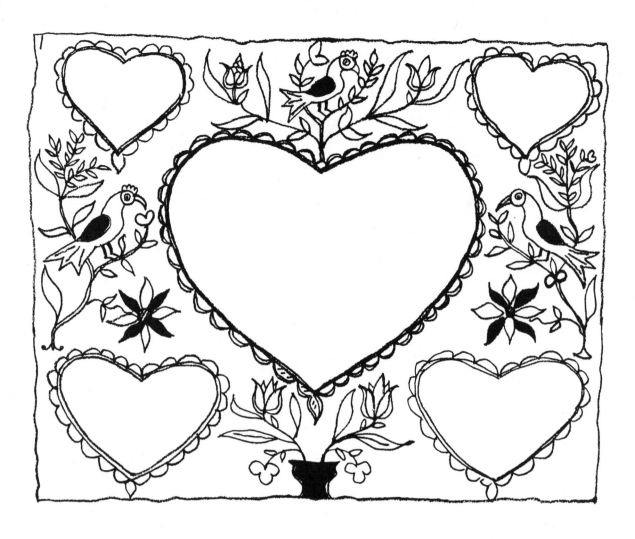

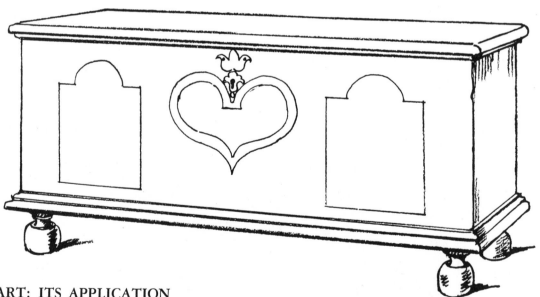

THE HEART: ITS APPLICATION

The early fractur writers, who were almost always schoolmasters or ministers, showed a decided preference for the heart in their work. Inside this form they inscribed the records desired by their clients. On many examples of birth certificates a large heart occupied the entire center of the paper. If the scrivener desired more space for inscriptions, he placed additional hearts in the corners (see above). These he filled with pious verses and appropriate religious texts.

After the printing presses began turning out a standard form of certificate from woodblocks, the wording was set in type inside the large heart, with blank spaces left to be filled in. By this time the *Taufschein* writer had become an itinerant and peddled the printed forms through the countryside.

Upper left: Four compass-drawn hearts, together with a simple form of barn symbol, adorn a carved mold used for shaping cakes.

Opposite page: Typical of many arrangements was the heart drawn with compass and set between two panels on the dower-chest face.

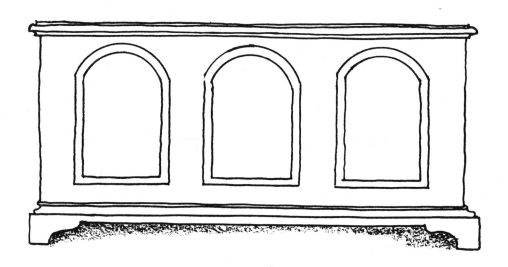

THE DOWER CHEST: ARRANGEMENT
OF PANELS

Decoration on the Pennsylvania German dower chest is of several types. On the simplest type, the front face is broken up by two or three panels. Within the confines of these panels is placed the main decoration. These panels, with arched, rectangular, or ogee-shaped tops, were usually painted on in white which has dulled through the years to a deep ivory. The background surrounding the panels was painted a dull blue, a dark green, red-brown, very rarely a yellow. Coloring on the earliest types was limited to red, blue, black, and white. Often the chests painted in brown were patterned with stippling, mottling, or sponging executed in a darker hue, though quite as frequently the panels were surrounded by a background of natural wood to which no color whatever had been applied.

The most elaborate chests have three sunken panels, set above two or three drawers; they were made by experienced cabinet makers, and are called "Lancaster County" chests. The sunken panels—which bore char-

acteristic decorations—were separated by fluted pilasters. These pilasters were also painted, and then dotted and streaked for further enrichment. Decorations were also placed on the ends and tops of most chests. While such embellishments frequently matched those on the face, often a different motif was used, especially on the ends.

The moldings around lid and base were painted in a contrasting color. The feet, whether bracket, trestle, turned, ball or bun-shaped, were colored according to the decorator's fancy. Occasionally barn symbols, stars, hearts, the name of the owner, and the date were added to diversify the usual layout of two or three panels.

For the most part these panels on chests are sharply defined against the background with a contrasting band of color. But now and then a decorator added sprays of tulips or other devices outside the boundary of the panel, to soften this harsh line and to provide additional ornamentation.

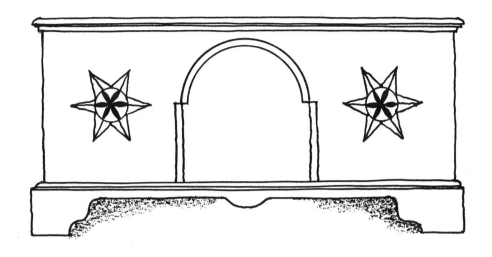

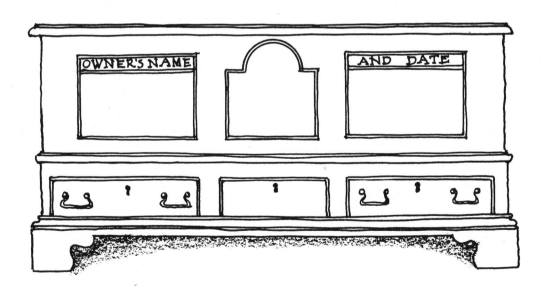

OWNER'S NAME AND DATE

FRAMES FOR INSCRIPTIONS: ON FRACTUR

Now and then the fractur writer turned to forms other than the heart as enclosures for the hand-lettered data he prepared for his clients. Of these forms the rectangle was the most obvious (see opposite above). The very rigidity of its outline, however, tempted him to embellish it. Placing a semicircular extension on top transformed it into a somewhat architectural form, and provided him

with additional space for decoration.

Opposite below: The horizontal rectangle, extended at sides with semicircles, became a simple type of cartouche.

Above: The circle, as an area in which to letter, was far from usual. The decoration is freely stated.

FRAMES FOR INSCRIPTIONS: ON DOWER CHESTS

When the chest decorator planned for lettering he placed it within the same kind of ornamental enclosure as did the fractur writer. But as lettering could itself be decorative, in some rare instances we find him using the inscription, not in a small cartouche (top, and second from top) but as a narrow ornamental band extending almost the width of the chest, the lettering being placed on a color which is in contrast to the general tone of the chest (bottom). These bands were rounded on the ends, forming a cartouche. Sometimes they were set as borders above the molded base. In the latter case the inscriptions, in German, stated ownership in some such fashion: "This chest belongs to me, Maria Miller, 1776," or: "Catherine Leiby of Oley owns this chest."

The lettering on chests, like that on birth-and-baptismal certificates, varied in quality of execution. When it was done in skilled fashion (and Gothic lettering was chosen for this) it often surpassed the decoration, but in most cases the ornamentation was the salient artistic feature, with the lettering taking second place. There are chests extant which are bare of ornament except for a cartouche enclosing the name of the owner. A favorite method of placing the name and date was on a narrow horizontal rectangle (bottom, and second from bottom). Simple ornamental devices such as tulips filled in blank spaces if the name did not take up all the area allotted to it.

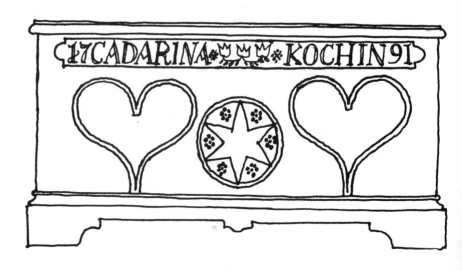

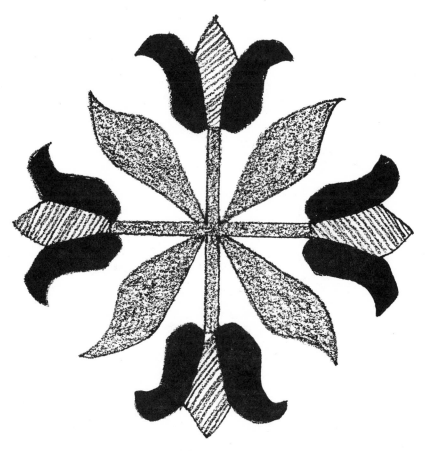

MOTIFS FROM APPLIQUÉ QUILTS

Although patterns obtained through geometric methods were the basis of all "pieced" quilts, the patterns for appliqué quilts were not made by mechanical means but by tracing round cardboard or paper forms cut free-hand with scissors. This method of making a design permitted a great deal of individual artistic expression. So did the method of execution, for the technique of appliqué is very simple. It consists of sewing a shaped piece of material onto a background of a different color, usually white, whereas "pieced work" is a mosaic of small geometric pieces of cloth sewn together in a prearranged pattern.

For appliqué quilts Pennsylvania German women chose motifs already familiar to us in these pages: the tulip, the heart, and the pomegranate, the urn, the basket, worked most often in the brightest of reds and greens. To these strong hues, beloved of the early quilt makers, were often added touches of blue, yellow, orange, or pink to diversify the scheme.

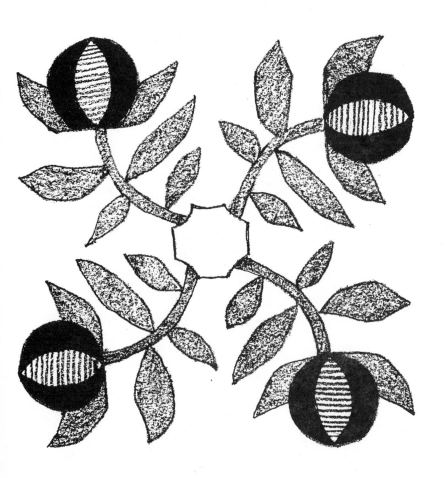

59

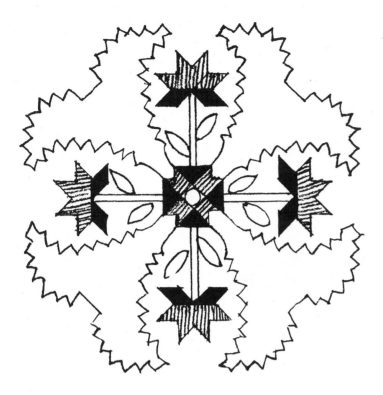

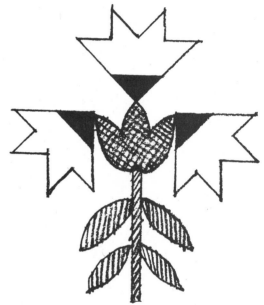

MOTIFS FROM APPLIQUÉ QUILTS

In Pennsylvania a flower design called the "Tiger Lily," a departure from traditional forms, was a very popular motif. Unlike most flowers which adorned quilts, it was not cut freehand but was constructed on a geometric plan, with four diamond-shaped pieces for petals and a triangle for calyx. This design as it passed on to other sections of the country was named after whatever wild lily was native to the region.

Upper left: A slightly altered type of "Tiger Lily" is combined with a local motif which appears in many different interpretations. Basically, it consists of a large form set diagonally, almost always cut from green calico. The pattern for this form was easily made by folding a piece of paper and snipping out a curved shape with notched edges. Details indicative of the needlewoman's preferences were added to this bold form.

Upper right: An interesting variation on the "Tiger Lily" motif is the handcut tulip, added to a pair of the standard geometrical type. The downward slant of the leaves, too, is original and provides effective contrast to other angles.

Lower right: As an unusual touch, small hearts are added to the familiar pomegranate, the latter worked in orange, red, and green.

(See also the two color illus. on the inside front & back covers)

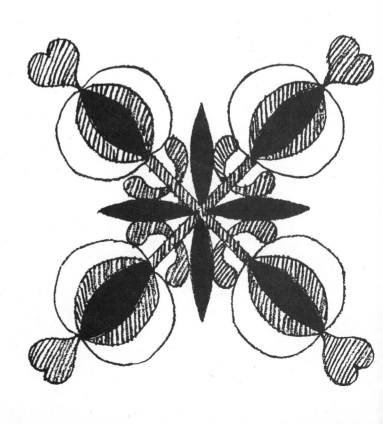

60

ENRICHING THE SURFACE

The overall effect of Pennsylvania German folk art is less elaborate than the peasant art of other countries. This simplicity results from the manner in which the motifs are used, not from the character of the motifs themselves, which fundamentally do not differ greatly in conception from those of the European peasant. But where the latter tended to cover every inch of a chest or wardrobe with carving or ornamental painting, the Pennsylvania artisan would usually restrict himself to unit motifs set within panels. These panels were surrounded by large areas of wood left either untouched, or painted and then worked over with mottling or stippling. This texturing was his method of achieving a semblance of patterning with comparatively little effort. When well done it was very effective.

Moreover it was attained by the simplest of means and material. By twirling the small end of a corn cob on a fresh coat of paint and spacing the whorls thus obtained closely together, he produced a freely painted surface pattern. Or he might take a crumpled piece of cloth, dip it into a contrasting color and apply it in rhythmic swirlings to give richness and decoration to an otherwise monotonous surface. A small piece of sponge, first touched lightly to the pigment and then to the painted surface, provided a stippled effect—a treatment often applied only to the drawers of a piece.

Really skilled artistans manipulated these humble materials to produce highly ornamental texturings. Experiments with such simple materials will demonstrate their possibilities to provide a rich effect.

To furnish ornament on a plain painted surface, a few decorators resorted to stamps cut in wood. The design was often no more than an elementary rosette, and was applied in most cases not with mathematical regularity, but freehand, spacing being judged by the eye with pleasing enough results.

In addition to the above treatments, areas within a motif were sometimes enriched with dottings of another color, or motifs were set off with an outline of dots (see page 25). But in general, outside the methods indicated above, there was little further experimentation in enrichment on the part of the decorators on wood.

The potter, in most instances, limited himself to the ornamentation provided by scratching a line on clay. When he went beyond this, he resorted to dottings or groupings of very short strokes. These gave additional tone to certain areas.

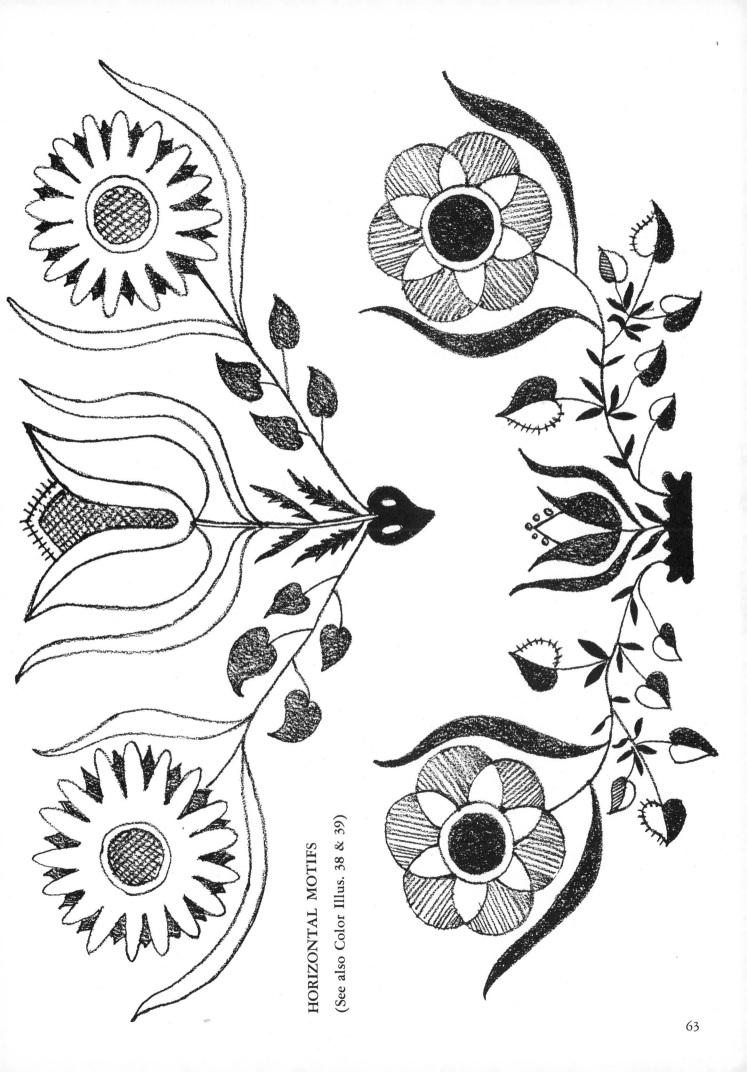

HORIZONTAL MOTIFS
(See also Color Illus. 38 & 39)

BORDERS

Generally speaking, there are few border designs in local Pennsylvania folk art, and those that were used were assembled from the simplest of design elements. This is because the problems posed in designing a border were complicated ones of measure and rhythm, and to execute them with the precision one looks for in borders, demanded more equipment than the average folk artist was likely to possess.

Occasionally, as a frame for the title page of a manuscript songbook, or a bookplate, or on a birth-and-baptismal certificate, the fractur writer would put together a border consisting of a repetition of quickly drawn pen strokes or hastily scrawled arcs and dots. Zigzag lines, too, were used as they could easily be spaced by the eye.

When faced with designing a border for a decorated plate, however, the potters were not let off so easily as the fractur artist. In ceramics German European tradition expected that the border on a plate be a lettered inscription. To make the lettering come out nicely, without leaving empty spaces, both judgment and skill were required. Some of the workers in clay, in Pennsylvania, finding themselves pressed for time or without the ability to letter, gave up this traditional idea. In its place, they substituted several circles (which could be inscribed mechanically on the wheel) and then decorated the space between the circles with a wavy line or some other easily drawn device.

Borders, however, constituted only a minor part of the chest decorator's design equipment. In a few instances the panels of decoration were outlined with a border made of zigzags and dots or some other facilely executed line motif. In most cases, however, the borders around the panels were flat bands of a contrasting color.

The large tulip border on the opposite page, taken from a fractur piece dated 1773, appears to be far more elaborate than the other borders taken from various folk art pieces. In reality, however, it is constructed on a basis of the most elementary of rhythms, a fact which accentuates its artless peasant charm.

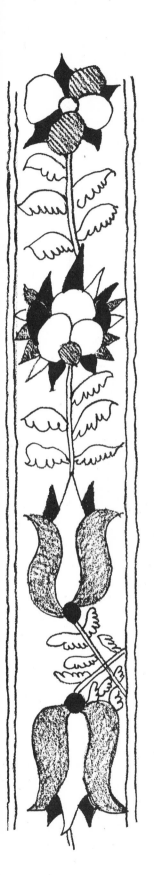
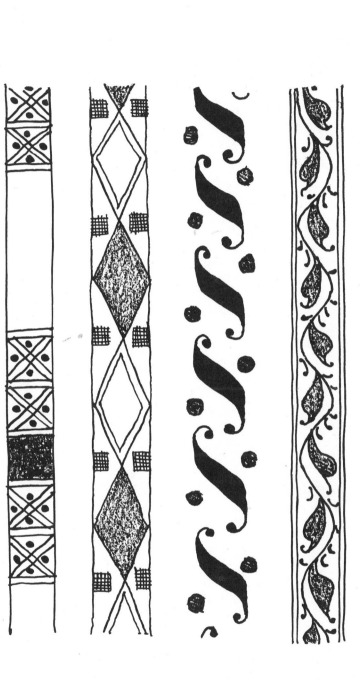
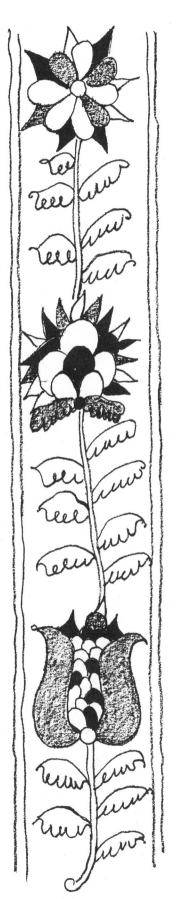

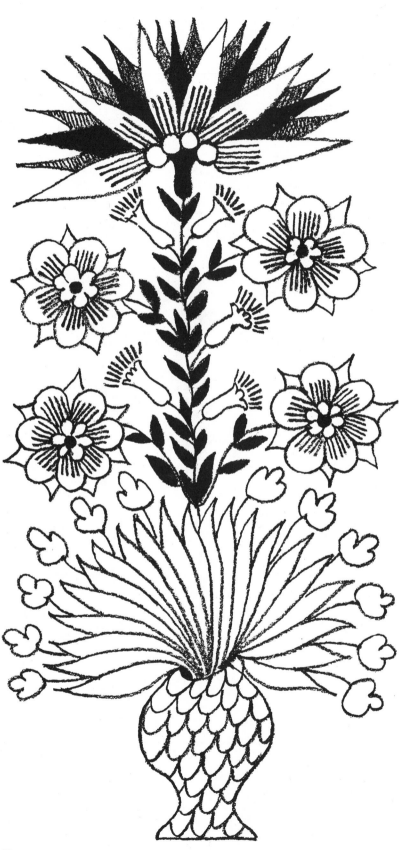

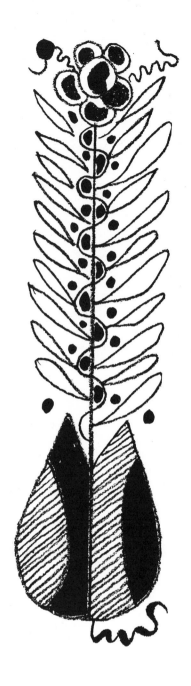

VERTICAL MOTIFS

The motif on the extreme left, taken from an early piece of fractur drawing, is signed by Johann Heinrich Otto, 1772, an outstanding decorator of the last quarter of the 18th century. All the design details which Otto employed during his working period are foreshadowed here, though he varied the arrangements and added other elements from time to time to fit the demands of space arrangement.

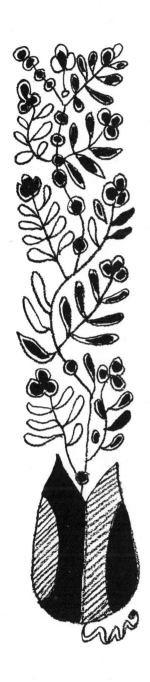

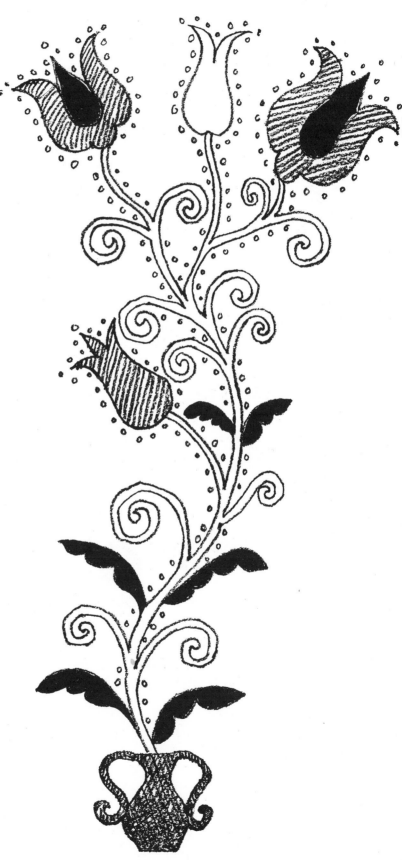

VERTICAL MOTIFS

Decorations with pronounced vertical extension are not found as frequently as are those more compact ones planned for rectangular areas, such as were used on panels of dower chests. The tulip design on the right was placed between such panels, which were arched at the top and equally elaborate in conception. The motif to the left was taken from a manuscript drawing, colored simply in vermilion and green.

1 2 3 4 5 6

LETTERING: ITS APPLICATION

The early settlers had but few belongings, so a sense of pride in one's possessions was only natural. In consequence objects were frequently marked with the owner's name. This is particularly true of dower chests, which often carry a date as well. For inscriptions on chests, the Roman alphabet (shown here), rather freely interpreted, was employed in most instances. These inscriptions in capitals were almost always conceived as part of the design, the characters dark against a light ground.

In lettering on birth certificates and on ceramics, a late form of German Gothic type was selected. It was called the "fractur" style, named after a type face itself based on manuscript writing. This, however, was far less rigid in character than the early black letter. The lettering on most objects fell far below professional standards, as there were but few really trained calligraphers in this country. Furthermore, the fractur writer used even the rather free forms of the fractur alphabet as he saw fit. When memory did not supply the shape of the desired letter, he invented one. This haphazard approach of the none-too-skilled resulted in lettering stamped with an engaging primitiveness. Therefore no one should hesitate to try lettering because of lack of experience. Equipped with an earnest approach, one can probably come closer to the spirit in which the early craftsmen worked than if one possesses too skilled a brush or pen.

7 8 9 0

ABCDEF
GHIKLM
NOPQRS
TVWXYZ

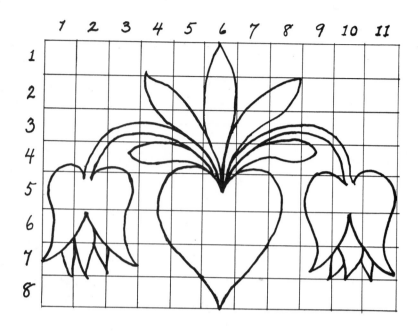

SUGGESTIONS FOR ENLARGING, FOR PAINTING

To decorate in the Pennsylvania German manner requires no particular artistic facility. In fact, too much skill in painting sometimes detracts from the untutored yet charming effect of folk decoration. In painting Pennsylvania German motifs the line or brush stroke should be a deliberate one, as though one were forced to reflect upon the direction of the line as well as the form. Pennsylvania German folk art motifs were never "dashed off," as was Swedish work, for example. This was because the decorators were rarely expert enough to attain what we today would call professional competence. Either they were self-taught or had learned as apprentices from persons who themselves had acquired a modicum of competence in like manner. Furthermore, though they worked for gain, the sparsely settled areas of early days did not produce enough orders in most fields of endeavor, so that they never acquired sufficient practice to become really proficient.

The character of folk design was affected not only by the medium in which it was executed but also by the surface to which it was applied. For example, the smooth surface of paper or painted wood permitted a certain freedom of execution with a brush. As a result this conveyed the impression that the decorating had been produced with ease. On the other hand, if one examines a line scratched in clay or cut in stone, it seems to be executed with much deliberation. This deliberation suggests that the craftsman, aware that these media allowed for no correction after a line was once established, proceeded very cautiously with his work. To realize the limitations set by the media themselves will enable one, in adopting folk motifs for contemporary purposes, to approximate the feeling of the folk artist towards his work.

TO ENLARGE

In adapting motifs from this book you may find that they are not exactly the size you desire for your particular purpose. There are two ways of enlarging them. The simplest is to have a photostatic enlargement made, if one is near an establishment which produces these prints. First decide on the size you want,

mark it on the design, either in the horizontal or vertical direction. It can be enlarged for you in the exact proportions of the original, and can then be traced from this photostatic enlargement. Photostats are made first as negatives and then as positives. For purposes of enlarging, the negative will suffice, and costs less.

TO ENLARGE FREEHAND

Take the design you wish to enlarge, divide it into any number of equal parts both vertically and horizontally, and number the squares thus obtained (see diagram). Then on a separate sheet of paper mark out a large panel in the size you have decided upon, divide it into the same number of squares as the smaller, numbering them also in the identical manner. Copy carefully into each of the larger squares the exact detail you find in the correspondingly numbered square of the original design. Then strengthen the lines with pencil or pen. Use thin or heavier paper, depending on which method of transferring you decide on.

METHOD OF WORKING

Again, there are several methods which can be used.

1. After copying your design on thin tracing paper, rub in a bright colored chalk on the back of the tracing (a color that is in contrast to the background on which you plan to work) and then fasten the tracing down firmly with scotch tape or thumbtacks on the background object or material. Trace with a hard pencil, which will leave a colored line on the surface for you to follow.

2. You can also transfer a design with red, yellow, or black carbon paper. Choose a color which will contrast with the color of the object or material on which you wish to place the design. Insert carbon sheet between pattern and object, then trace the pattern.

3. If you have made a drawing on stronger paper, such as manila, you can transfer it by "pouncing" it. Pouncing is a method of transferring a colored powder through pin-pricked outlines. To prepare the "pounce," take a strong pin and prick the outlines of the design, spacing the pinholes about ⅛ inch apart. Fasten the pattern firmly to the background or material to which you wish to transfer the motif. Take powdered wash-blue or pulverize a strongly colored piece of chalk, tie it tightly in a piece of thin muslin and rub over the pin-pricked outlines. The line of colored dots which result should be strengthened at once with a soft pencil or crayon before they rub off.

TO TRANSFER A DESIGN

Keep the article flat when transferring a design by any of these methods. It makes the operation easier and is also the best position for decorating. When using oil paint you will have a better result if you employ something on which to steady your hand. The professional uses a "mahl-stick." To make a "mahl-stick," take a smooth stick about two or three feet long (a ½-inch dowel is fine). Tie a small pad of cloth firmly to one end. Hold the stick in your left hand with the padded tip resting firmly against any convenient surface a few inches above your work. Support your right hand on it when painting. With its help, you will be able to steady your brush and also avoid smudging freshly painted areas.

COLORS

In early days the colors used by the folk decorator were few in number (see page 24). As the motifs in this book are applicable to a wide range of purposes, crafts, and media, no further suggestion as to the placement of color beyond that given by the color plates will be made. Information as to the background color for painted chests is given on page 54.